750.92 RAY
GL

D1325882

Man Ray

EVESHAM COLLEGE
750.92
RAY
LIBRARY
30717

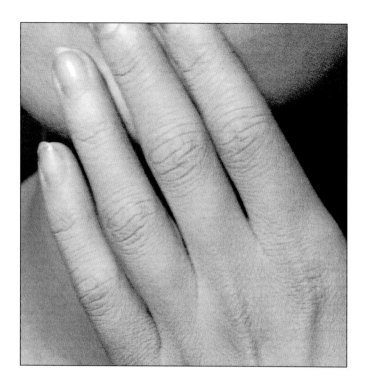

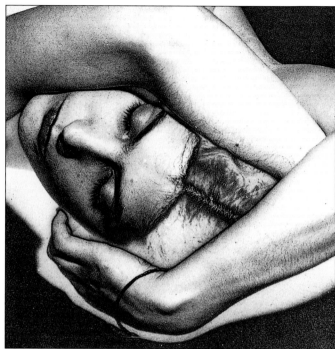

© 2005 Sirrocco, London, UK (English version)
© 2005 Confidential Concepts, worldwide, USA
© 2005 Estate Man Ray / Artists Rights Society, New York, USA /
 ADAGP, Paris

ISBN 1-84013-763-0

Published in 2005 by Grange Books
an imprint of Grange Book Plc
The Grange Kingsnorth Industrial Estate
Hoo, nr Rochester, Kent ME3 9ND
www.Grangebooks.co.uk

Printed in China

All rights reserved. No part of this book may be reproduced or adapted
without the permission of the copyright holder, throughout the world.

Unless otherwise specified, copyright on the works reproduced
lies with the respective photographers. Despite intensive research, it
has not always been possible to establish copyright ownership. Where
this is the case, we would appreciate notification.

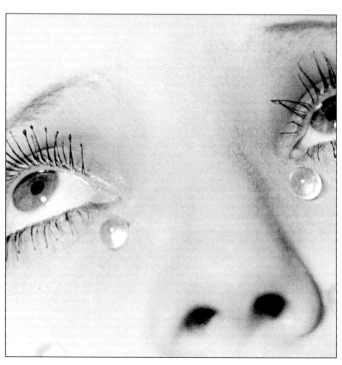

Man Ray

Grange
BOOKS

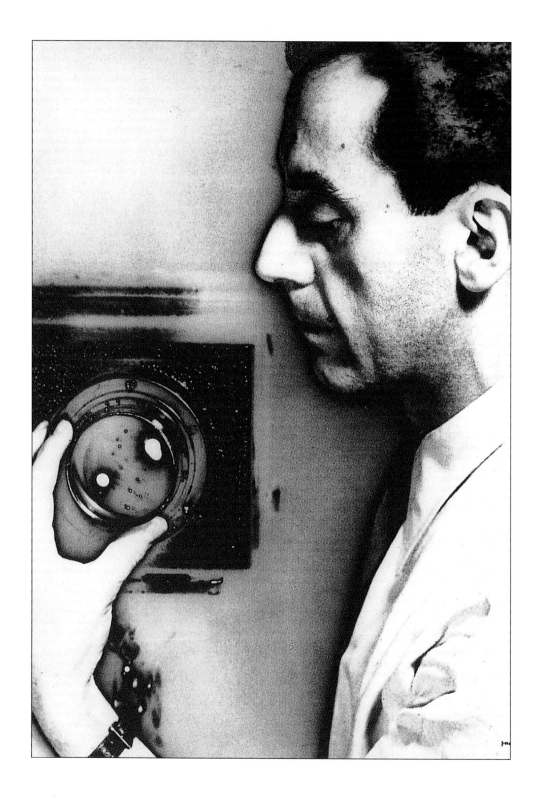

Photographer, artist, film-maker, poet, surrealist: Man Ray was one of the most versatile and prolific artistic figures of the century and someone who put his stamp on several emerging art forms. His versatility was not limited to his work in the studio, however. As a lover, he was associated with some of the most famous and talked-about women of modern times. As a photographer, he pursued women as if he were racing against time, endlessly framing and re-framing them to produce some of the most intimate and sensual images ever caught on film.

Some artists are sparing in their use of models, preferring to keep their sexual partners to themselves. Man Ray was the complete opposite. His paintings, and in particular his photographs, are the journal of his sexual and emotional development. In the process, he created some of the most eye-catching, sensual and graphic images of men and women ever created. Emmanuel Radnitsky, born in 1890 to a mother who liked to make her own clothes and a father who toiled in a garment factory, moved with his family from Philadelphia to New York and back again as his father looked for work. Young Emmanuel was followed by a brother and two sisters, the youngest of whom, Elsie, was his only real friend in the family. Young Emmanuel showed artistic leanings from an early age. So much so, that at the age of twenty-one, he felt sure enough of his future to leave Philadelphia and head for New York, in order to become an artist.

Part of the attraction of New York was the art gallery owned by the photographer Alfred Stieglitz, located on Fifth Avenue and Thirtieth Street. Stieglitz was an unapologetic missionary for modern European art, introducing the American public to the Cubist works of Picasso, as well as Rodin, Cézanne, Renoir and van Gogh, breaking down barriers between painting, photography and other art forms. Stieglitz met Emmanuel Radnitsky and liked the look of him. At around the same time, Emmanuel was in the process of deciding on a change of name - to the altogether more manageable Man Ray. Man Ray enrolled at the Ferrer School of Art in 1912, where he fell under the spell of Robert Henri, whose encouragement to his students to draw at high speed struck a chord with Man Ray. It was a thrilling time to be a champion of Modernism.

Everyone was talking about Europe, seeking out the latest news and reviews from Paris. Man Ray soon made the acquaintance of Marcel Duchamp, who was to be his lifelong friend. He was stunned by Duchamp's radical style, such as his *Nude Descending the Staircase* (1913), which was mockingly described in contemporary newspapers as a "collection of saddle-bags", an "explosion in a shingle factory" or "Slats Falling Down Stairs". Their friendship continued to deepen through 1915 as Duchamp worked on his even more breathtaking work *The Bride Stripped Bare... (La Mariée mise à nue par ses Célibataires, même.)*

1. *Man Ray*, 1931,
 Solarization.

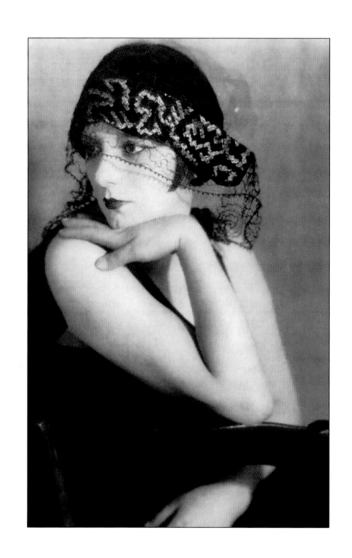

2. *Kiki de Montparnasse*,
 1924, Triple portrait,
 extract from Fernand
 Léger's "Ballett
 Mécanique",
 Photograph.

3. *Long Hair,* Photograph,
 40.5 x 30 cm,
 Private Collection, Paris.

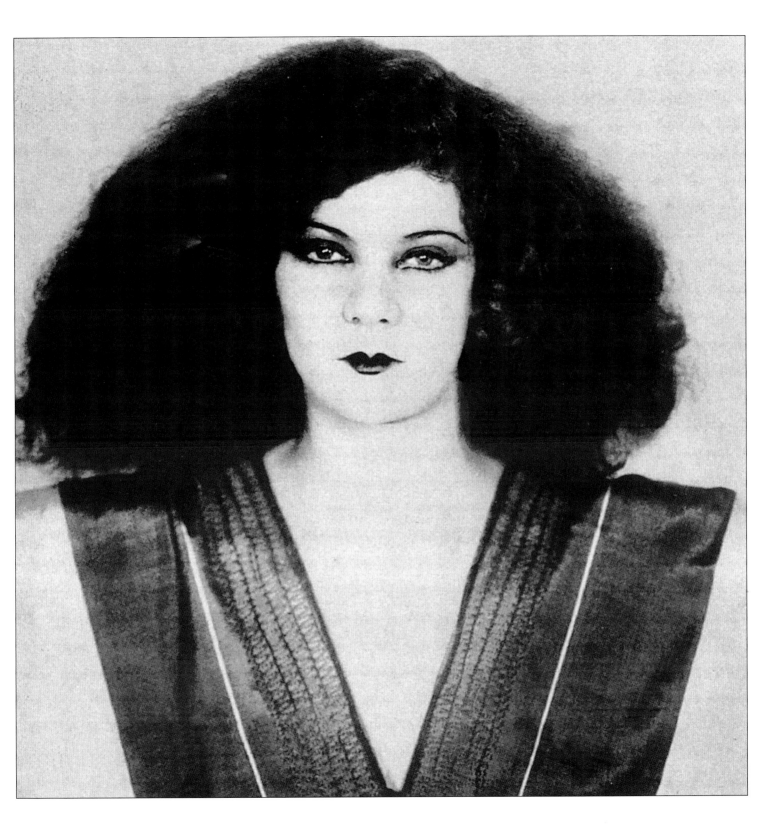

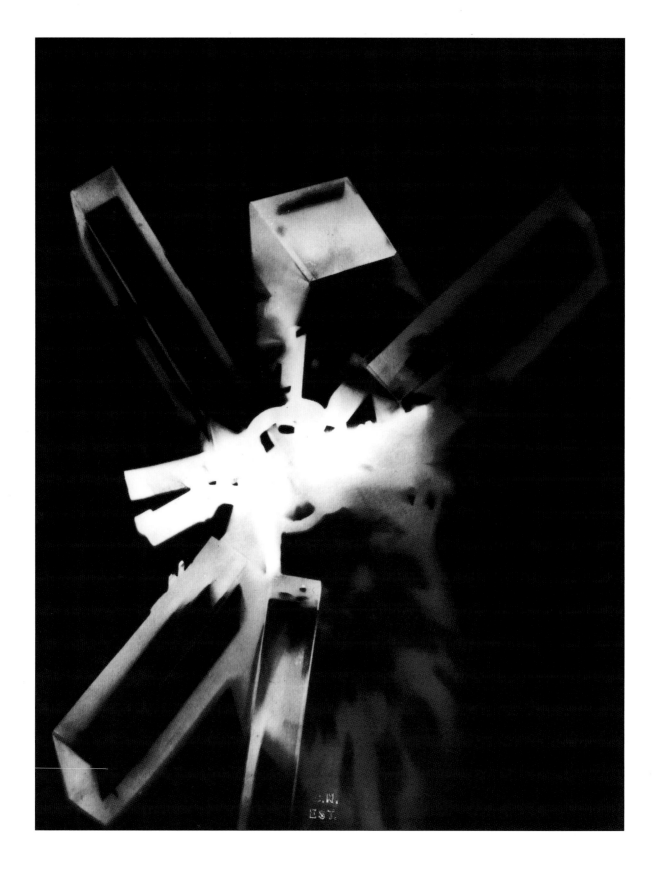

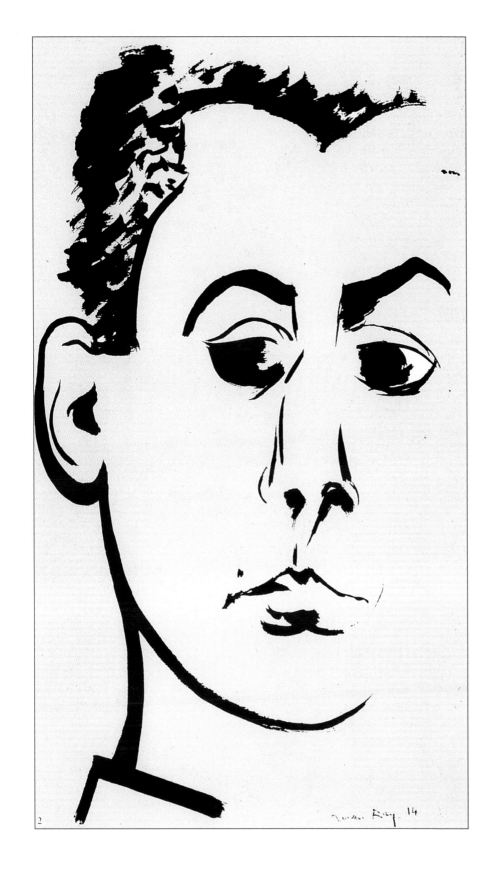

2

4. *Rayograph*, 1923,
 Black and white
 Photograph,
 49 x 39.5 cm,
 Private Collection.

5. *Self Portrait*, 1914,
 Ink on paper,
 42.5 x 30 cm,
 Private Collection.

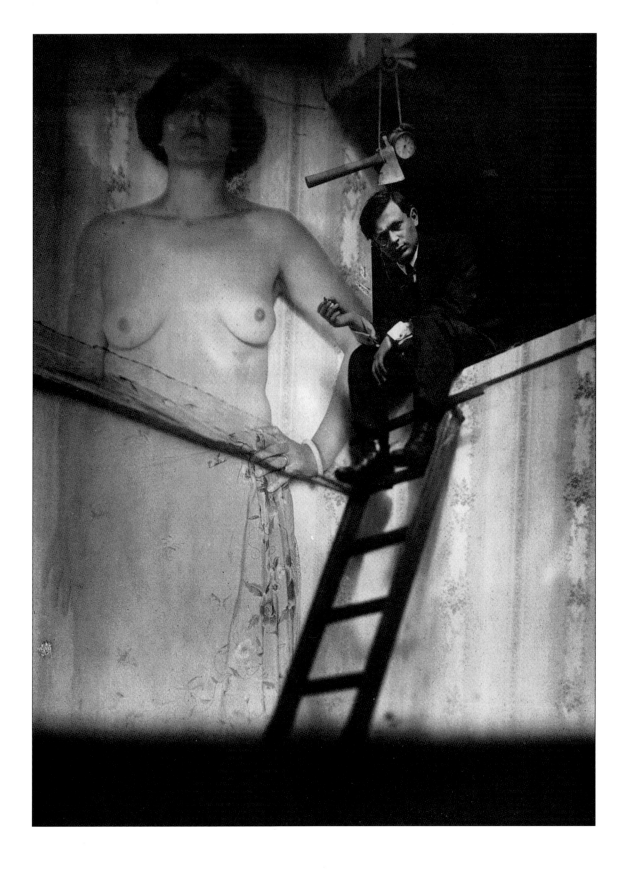

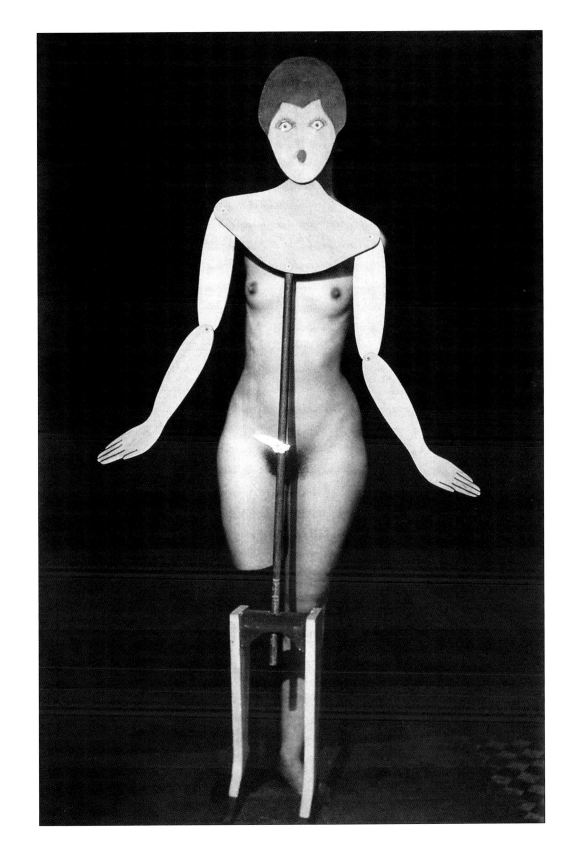

6. *Tristan Tzara,* 1921,
 Photograph.

7. *Coat Stand,* 1920,
 Photograph,
 23.7 x 15.6 cm.

A year later, in 1916, while war raged in Europe, Man Ray produced his own highly conceptual oil painting, *The Rope Dancer Accompanies Herself with her Shadows*. The influence was clear even from the narrative style of the painting's title. Man Ray's relations with his parents were never easy. He regarded his father as too soft, and his mother as too hard, which made for an uncomfortable relationship. They tried to support his painting ambitions, but he never responded warmly to them. Instead, and perhaps to compensate for his difficult relationship with his mother, he embarked on a series of volatile relationships with women.

In 1913, at the age of twenty-three, Man Ray and his friend Sam Halpert rented a house in the small town of Ridgefield, New Jersey. He needed to be away from the city for a while, to give himself time to digest the full impact of his first exposure to Cubist art at Alfred Stieglitz's 291 Gallery. Stieglitz had urged him to attend the International Exhibition of Modern Art, known generally as the Armory Show. Man Ray needed little prompting to go and see for himself.

It was while he was staying in Ridgefield, painting Cubist-influenced landscapes, that he got to know the recently divorced Adon Lacroix. The former wife of Adolf Wolff was a tall, blonde poet from Belgium who spoke French. They met in 1913 and he pursued her with feverish intensity, pouring his innermost erotic fantasies into his private journal:

"Oh, talk about the whole world and tell it in your own way. I am very quiet and interested when you talk that way... I unbind your strange pale hair which falls down about your strange pale face and rests on your pale shoulders. My hands tremble then as they tremble when I hold the pencil to draw from you."

He drew her, or drew "from" her, obsessively, creating conversations in his journal that he would have liked to have with her. "I should like to draw from you very much if you were my wife. When you are my wife and I sit down to draw from you I shall not think about drawing. When you are my wife and I start to draw from you, I shall think about you... then, when your hair is down I would stroke you. And while I stroked you, you would purr, purr, purr."

The effort paid off, and they were married the following year. They continued to write poems to each other, but by 1915 he was becoming more and more interested in exploring the possibilities of the still new art form - photography. Among Alfred Stieglitz's contributions to New York art life was a periodical for the expression of radical views called Camera World. In it, Man Ray came across a controversial essay by the Mexican critic Marius de Zaya proclaiming that "Photography Is Not Art". The merits of this still emerging craft were being hotly debated in every art house, gallery, café or salon in New York, but de Zaya's denunciation affected Man Ray strongly, and he returned to it several times during his life, though always with a surprisingly different answer.

8. *Aviary,* 1919, Gouache, pencil, pen and ink on cardboard, Scottish National Gallery of Modern Art, Edinburgh.

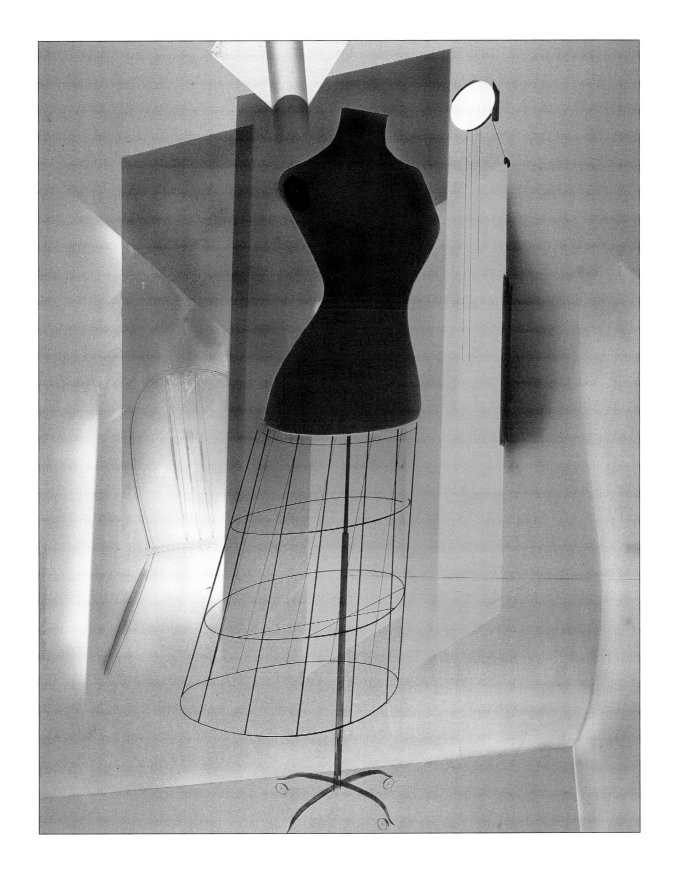

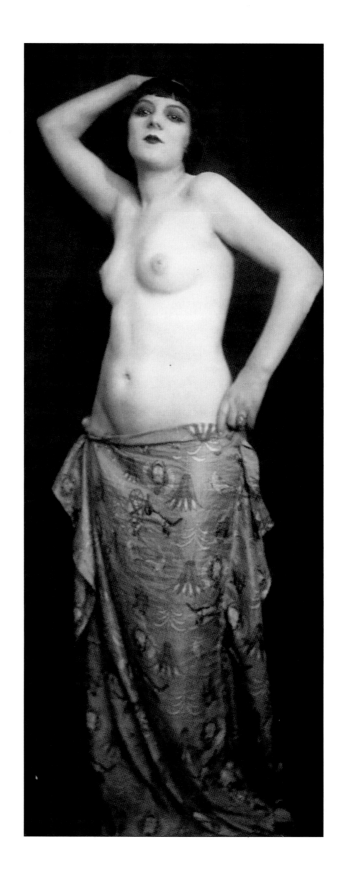

9. *Kiki de Montparnasse*,
1922, Photograph.

10. *Violon d'Ingres (Kiki
de Montparnasse)*,
1924, Photograph,
30 x 24 cm,
Private Collection,
Paris.

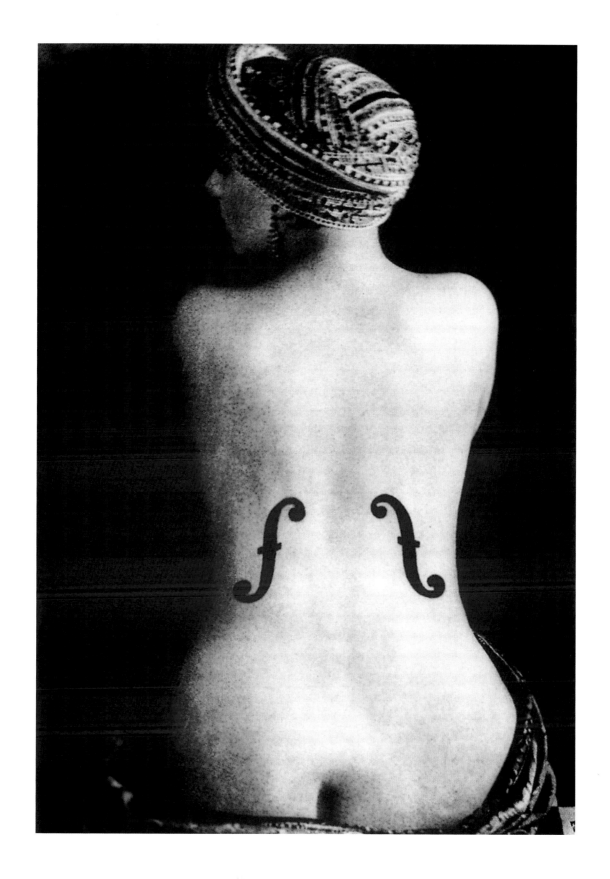

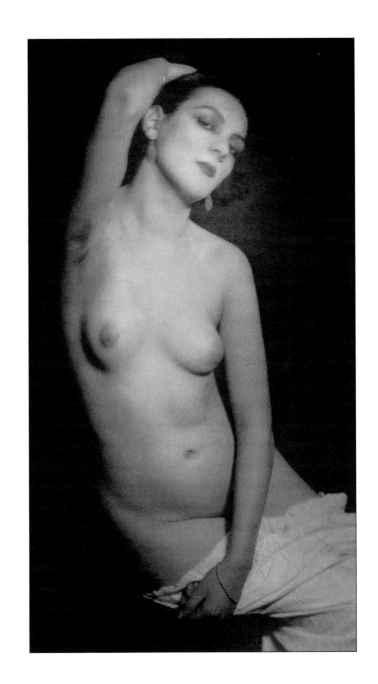

11. *Kiki de Montparnasse*,
 c. 1922, Photograph.

12. *Pavillon de
 l'Élégance*, 1925,
 Wooden Figure for the
 "International
 exhibition for
 decorative arts",
 Photograph.

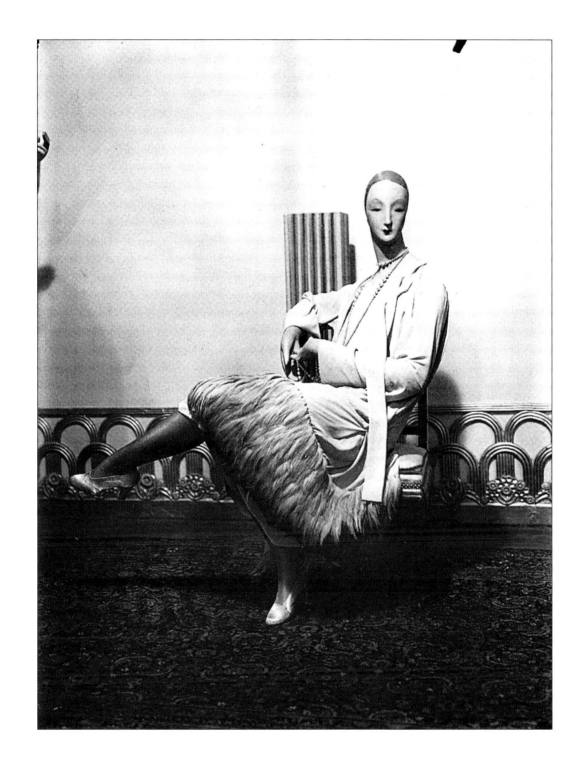

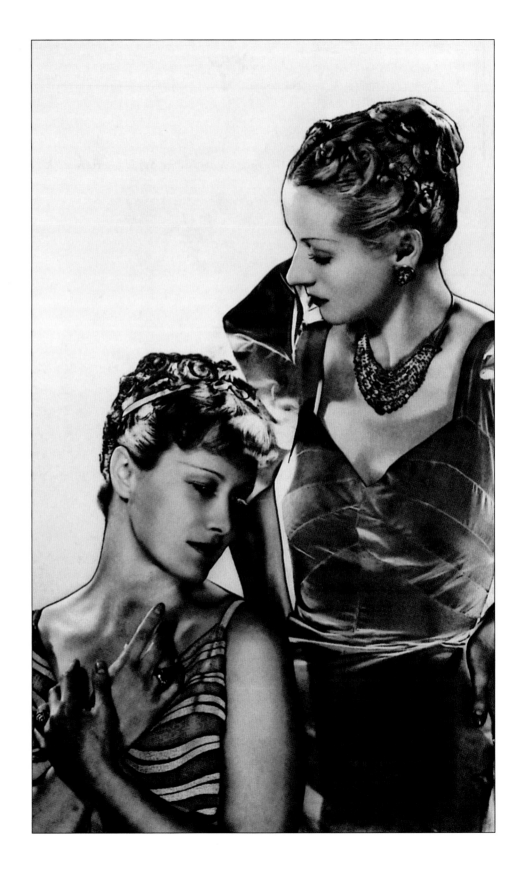

13. *Fashion Photograph*,
 c. 1930,
 Solarization.

14. *Veiled Erotic*, Meret
 Oppenheim, 1933,
 Photograph.

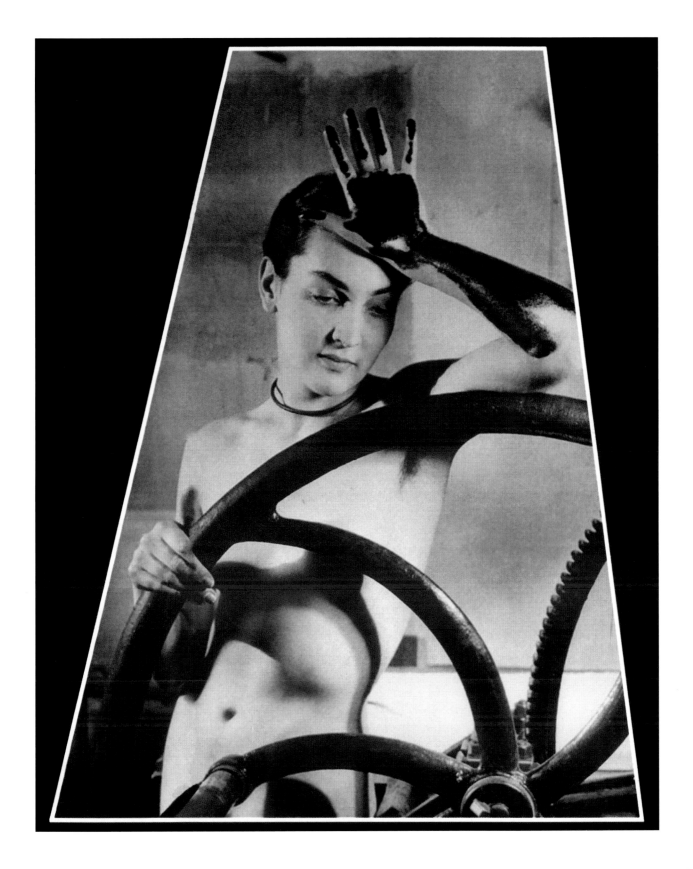

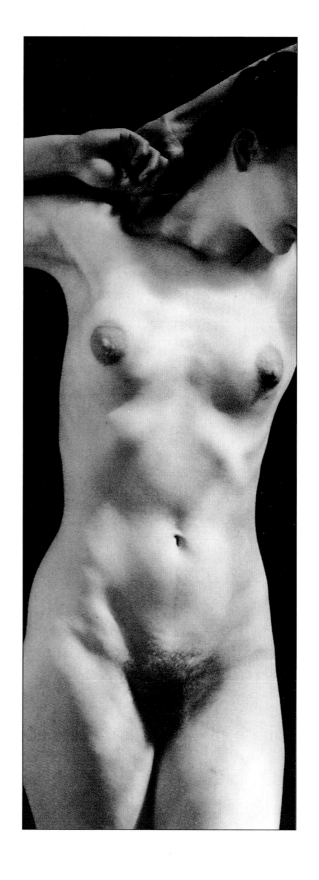

15. *Untitled*, 1927,
 Photograph.

Many years later, he would say: "I paint what cannot be photographed, and I photograph what I do not wish to paint." Even now, it sounds somewhere between a defence and an apology, as if he cannot make up his mind about the virtues of either. By 1918, Man Ray's marriage with Adon, or Donna as he called her, was under strain. She flirted with other women, and he took solace with women friends. One was Berenice Abbott, from Springfield, Ohio. Another was her friend, the journalist and poet Djuna Barnes, whom one admirer praised for her "long neck arched swanlike, exquisitely chiselled profile, and ever-present cigarette in its holder." It wasn't too long before his marriage to Adon was over. Convinced that his future lay in Europe, Man Ray took the boat to Paris in July of 1921.

By the time Marcel Duchamp joined him there, Man Ray had decided to become a professional photographer. He photographed Marcel Proust on his death-bed, and he quickly got to know, and to photograph, James Joyce and Gertrude Stein. All the time though, he was looking for new ways to propel this most plastic of arts. In the winter of 1921-22, he showed his friend, the poet Tristan Tzara, a new technique, which he had invented. By experimenting in the dark room with light sources and developing fluid he found a way to produce images that had a weird, silhouette-like quality. To a modern eye they look like objects floating through an X-ray machine in zero gravity, seen as if in a dream. Light itself was an instrument, to be wielded just like a brush. This alternative to conventional photography became known, in tribute to its inventor, as the *Rayograph*. To the young Man Ray, it made photography look as fluid and dynamic as painting seemed constrained, static and old-fashioned.

It was in Paris that Man Ray met his next muse, Kiki de Montparnasse. Kiki was born with the name Alice Prin in the farm country of Châtillon-sur-Seine near Burgundy. She came to Paris in search of excitement, adventure, and romance. Like the former Emmanuel Radnitsky, she changed her name to something more dashing and became known as Kiki, or Kiki de Montparnasse. Both she and Ray seemed to be looking for something similar, and few people were surprised when, soon after their chance meeting, they became lovers. Man Ray was not the only artist she sat for, but the images she inspired him to create are some of the most openly erotic ever produced. Certainly they are milestones in the history of photography. The most famous is probably *Le Violon d'Ingres*, which dates from 1924. The title is a play on words, "violon d'Ingres" being the French phrase for a hobby. Man Ray made much of this mischievous pun. Kiki appears in the photo, back to the camera, in the same pose as Ingres's model though with her head turned the other way, and with an exotic turban and earrings round her head. But the famous, exquisite final touch is the two f-shaped sound-holes of the violin that adorn her back.

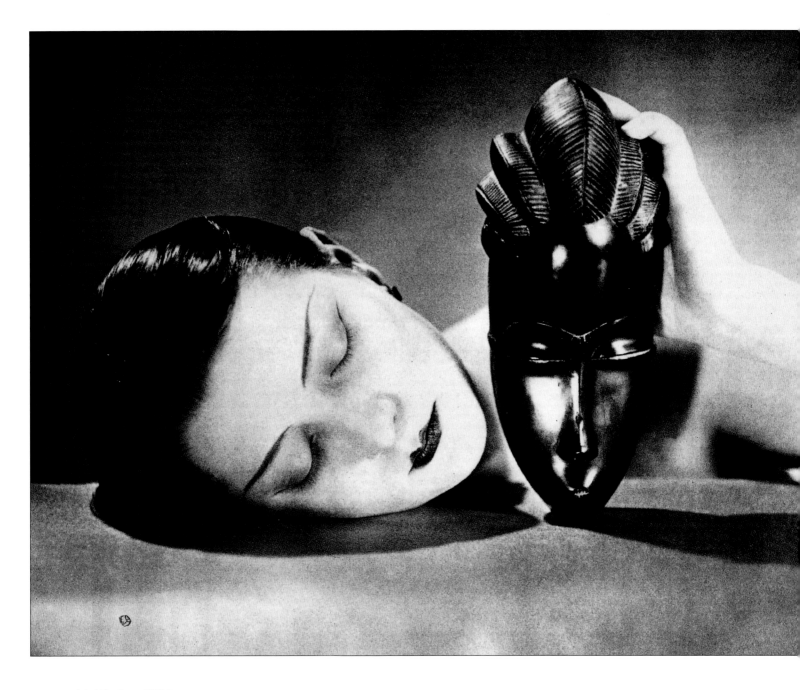

16. *Black and White,*
1926, Photograph,
24 x 30 cm,
Private Collection,
Paris.

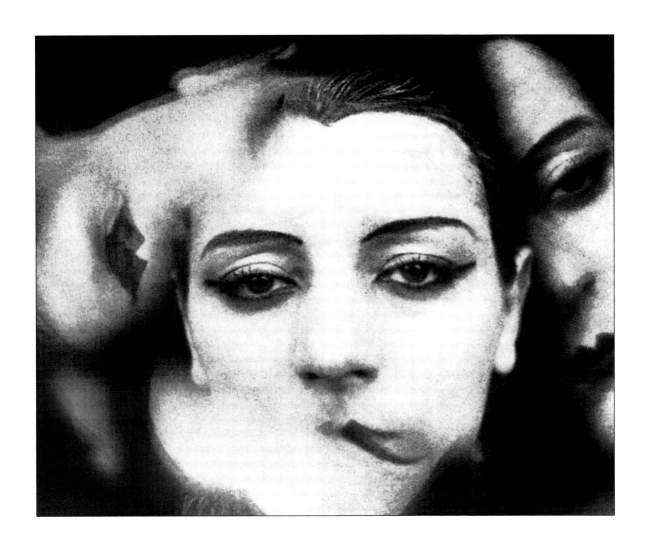

17. *Kiki de Montparnasse*,
1926, Photograph.

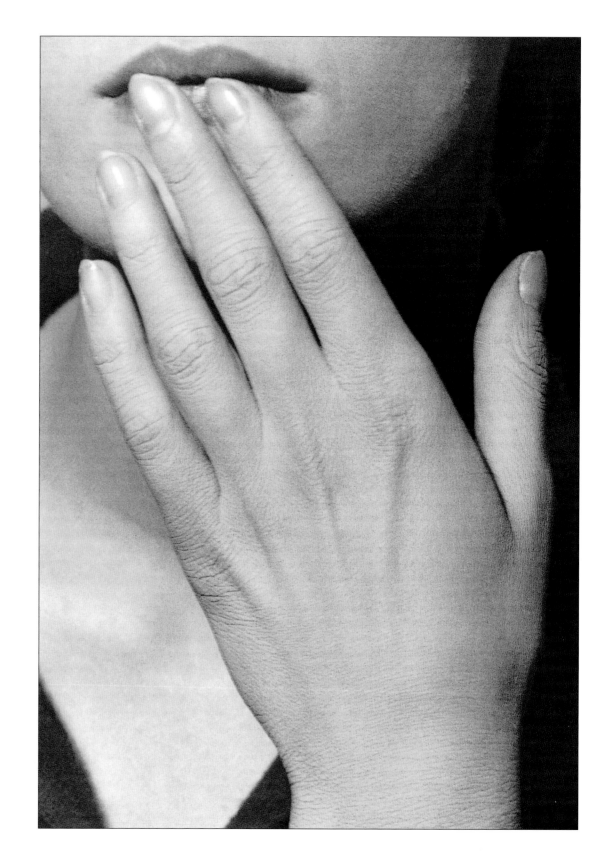

18. *Untitled*, 1931,
 Photograph.

19. *Rayograph*, 1927,
 Black and white
 Photograph,
 Private Collection.

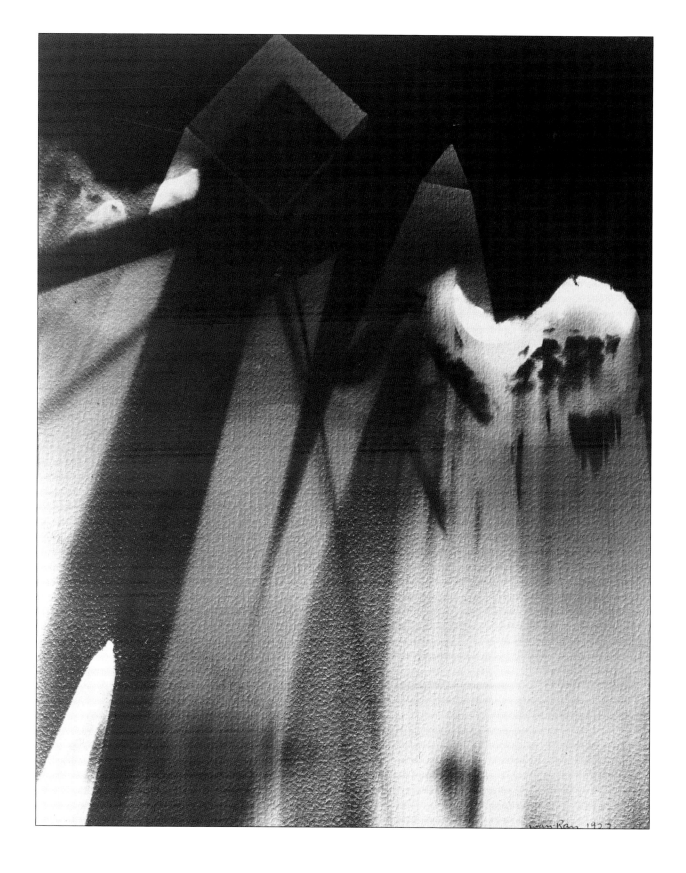

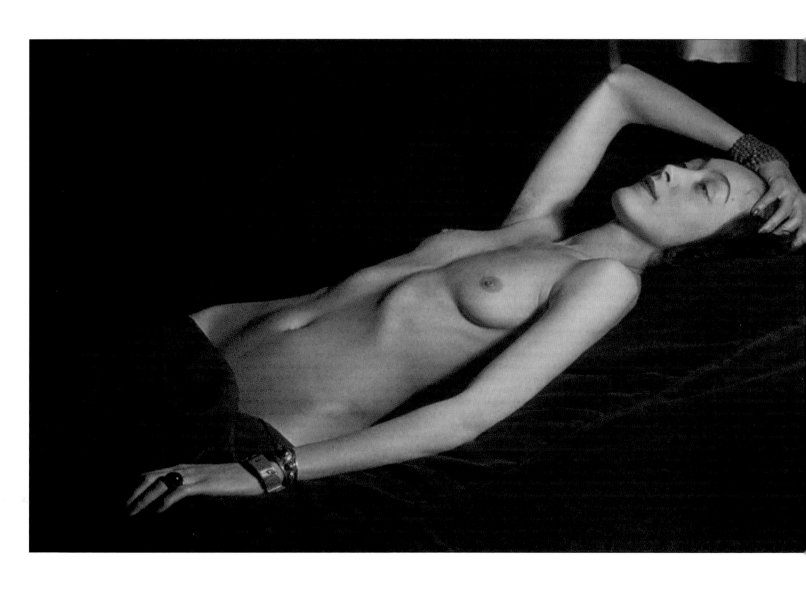

20. *Untitled*, 1928,
 Photograph.

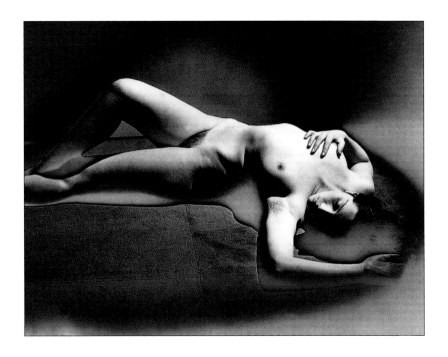

The woman's back is in itself an instrument, and one that the skilled player (the lover) can coax into life with his (or her) hands. By transferring the image from the violin to her back by contact photography, Ray formed a link between "two distant realities", a game the Surrealists loved to play. The suggestive title implies that, by transforming his model into an object, Kiki has become a toy or a plaything for Man Ray, though one of Ray's biographers, Arturo Schwarz, insists that Ray was keener to suggest that "photography was for him merely his 'violon d'Ingres'; his real interest lay elsewhere." For others, such as the American critic Neil Baldwin, what makes "Le violon d'Ingres" a Surrealist classic is its acknowledgement, even its deference, to the work by Ingres that preceded it.

Man Ray and Kiki were one of that colourful decade's most talked-about couples. Only just in her twenties when they met, Ray took the girl and, quite literally, remodelled her. Every night, before they went out, Ray would shave her eyebrows and then repaint them in whichever colour, angle or thickness he wished. Then he would turn to her eyelids, transforming them into cobalt blue one day, or jade the next day. Her caps and dresses were stunning, and sometimes quite revealing. They lived together for six years, during which time she referred to herself as "Kiki Man Ray". When Man Ray was away, his place in bed was taken by Kiki's soul mate, Thérèse Treize. The three were the best of friends, often venturing out together to Hilaire Hiler's Jockey Club at the end of their street, where Kiki sang in front of an audience of swooning men, and some women.

21. *Matter primes
 thought*, 1929,
 Solarization,
 22 x 30 cm,
 Arturo Schwartz
 Collection, Milan.

Paris in the 1920s was a magnet for artists, but photographers were fewer in number. In the case of Man Ray, however, this only added to his allure, and though Kiki might have had reservations at first about posing in front of his invasive lens, she soon overcame her shyness. Having previously sat for many of the artists plying the streets of Paris's busy artistic districts in return for a decent meal or a couple of drinks, she now became Man Ray's principal subject. In so doing, she had to set aside her own artistic ambitions for a while, as Man Ray - what a familiar story! - felt threatened by her efforts. Whatever this cost her in terms of her own œuvre, Man Ray would have been a less accomplished photographer without her. Clothed or nude, hitching her skirts up to mid-thigh or with her body bathed in delicate lighting, she is, says Baldwin, "the veritable epitome of the roaring Twenties". Naked, the body of Kiki is voluptuous, broad in the hip and with a Rubenesque belly. She poses, eyes sometimes turned away from the lens as if she doesn't know, or care, what positions the photographer is pleading with her to maintain. In portraits, the face of Kiki is not that of a classical beauty. There is something coarse but life-affirming about that broad nose, the lips parted in an over-familiar grin, and those big, jauntily smiling eyes. She was, truly, *jolie laide*.

The first important date in Man Ray's film career, set against the dying embers of Dadaism as a truly radical artistic movement in Paris, is 1923, the year of The Return to Reason. Its first screening was overshadowed by riots, with poets and actors trading blows on stage during the performance of a play by Tristan Tzara. The audience were thus spared the sight of a headless woman's nude torso, breasts turned anonymously toward the viewer, her flesh the backdrop for a pattern of black and white stripes, worn like a skin but which only seemed to emphasise her nakedness. Seven years later, a headless image of Lee Miller, breasts turned squarely to the camera, played with the same image, the chequered light pattern throwing a snakeskin of light onto her chest and stomach.

The relationship with Kiki did not last. Like the flash of a lightbulb, it produced much light for a short while before dying away. By 1928, Man Ray and Kiki were not happy lovers. Their arguments were becoming more frequent, as well as more high-pitched. Kiki moved out, and wrote a book about her former lovers, including Ray. If he was angry, consolation was not long in coming. In the summer of 1929, he was introduced to a stylish young Canadian photography student in her twenties called Lee Miller. She unashamedly announced herself as his new assistant. Man Ray was taken aback, as much by her boyish beauty as by her sheer front. He tried to parry her advances by declaring that he was off to Biarritz the next day. "So am I" was her response. So began an affair that, for three years, was to be the most intense and profound of his life.

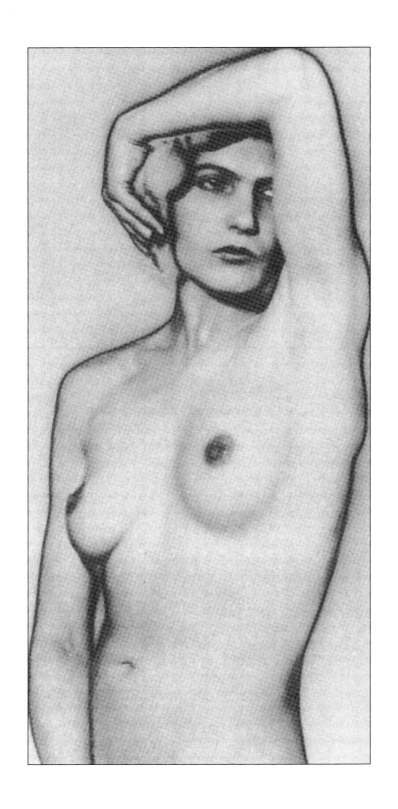

22. *Natacha*, c. 1930,
Photograph,
30 x 22.5 cm.

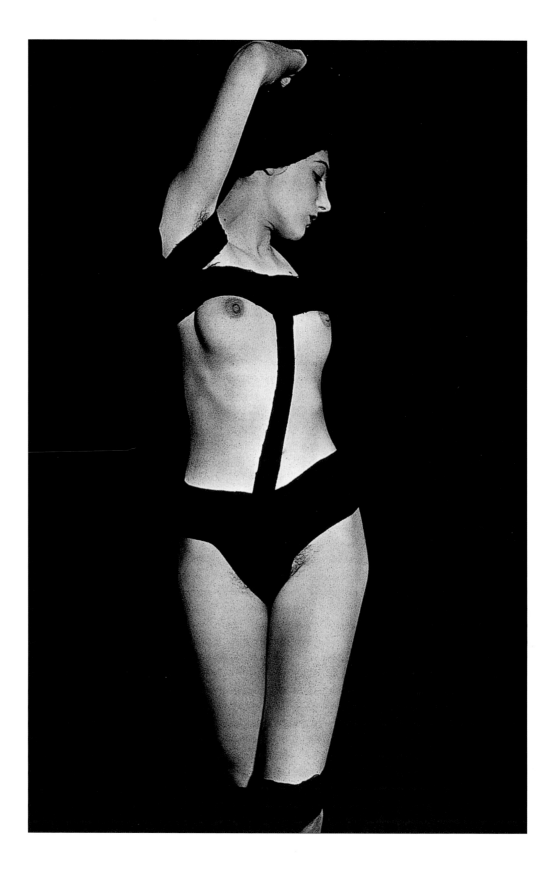

23. *White and Black (variation)*, c. 1929, Photograph.

24. *Black back*, 1929, Solarization.

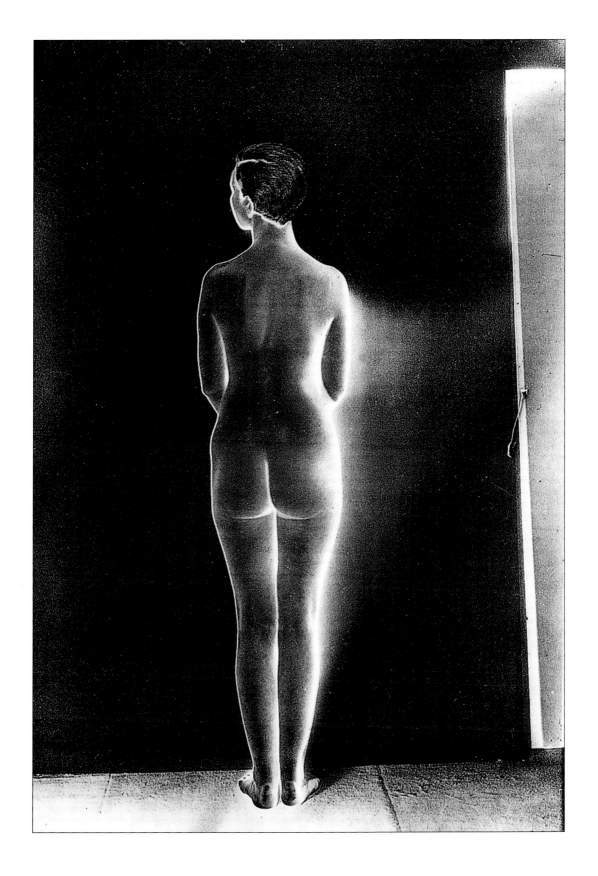

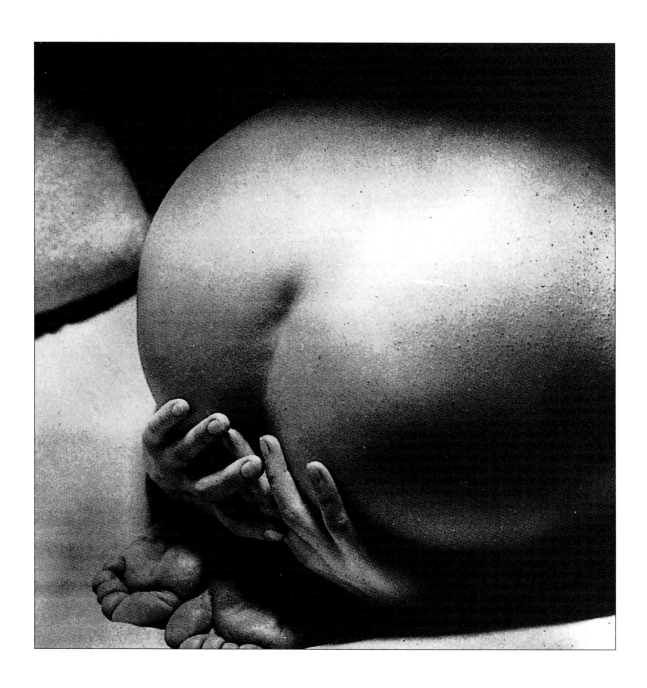

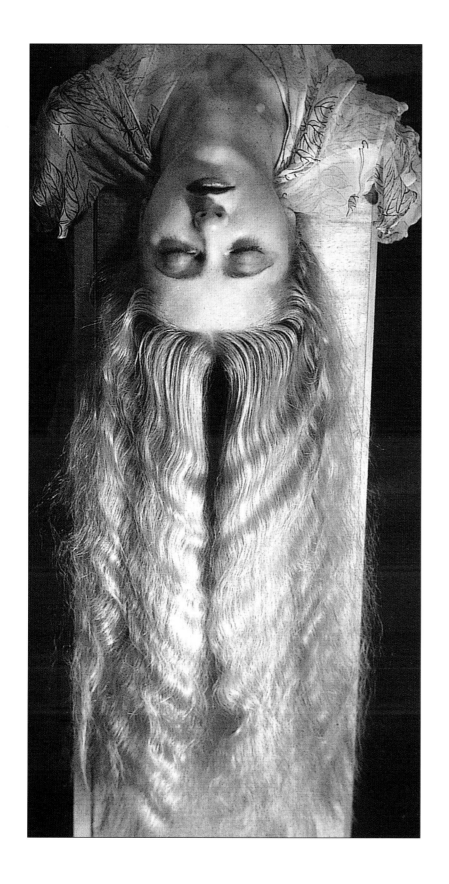

25. *The Prayer*,
1930, Photograph,
23 x 17 cm,
Paolo Rosselli
Collection, Milan.

26. *Long Hair*, 1929,
Photograph.

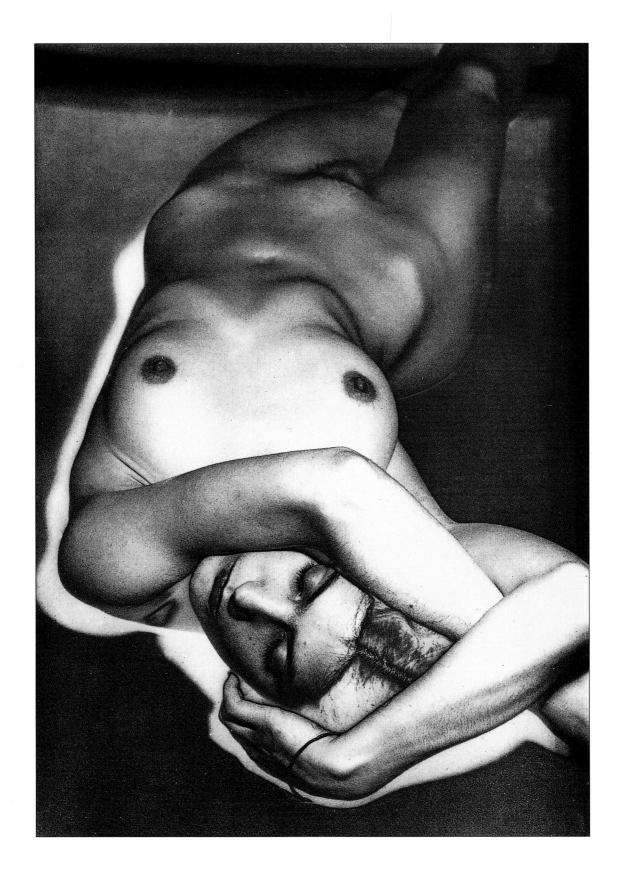

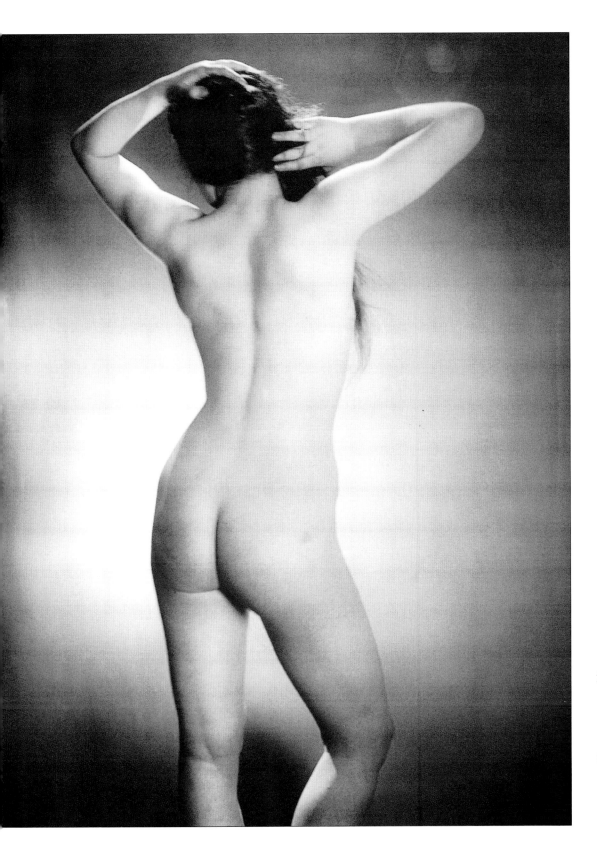

27. *Natacha*, 1929,
 Solarization,
 24 x 30.5 cm.

28. *Nude*, 1929,
 Photograph.

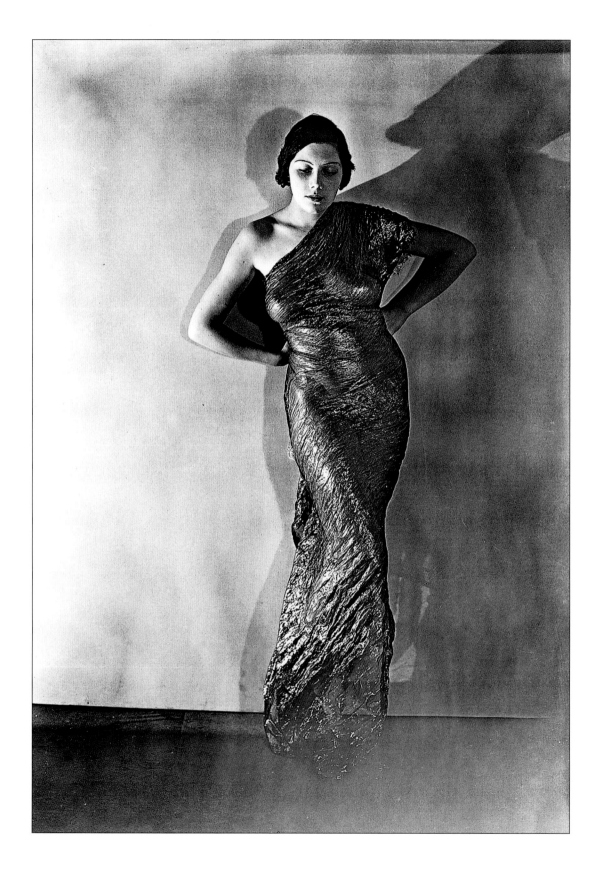

Lee Miller and Man Ray worked and lived together, though keeping separate apartments, as photographer/model, and, inevitably, man/woman. In the tiny darkroom ("which wasn't as big as a bathroom rug", she later said) at his new studio in the Fifth Arrondissement, their working relationship was too close to be called that of photographer and assistant. Indeed, though Man Ray claimed not to mind that Miller's own reputation as a photographer was growing, she later alleged that some of his pictures were hers, not his. Unlike the photos of Kiki, there is no jokiness in his studies of Lee Miller. It is as if his obsession with her precludes anything but the purest desire to portray her beauty. He never appears with her, she is always alone, unchallenged. In one, from 1930, Man Ray fashioned her, as he did with other models, like a Greek sculpture, complete with the truncated arms of a latter-day Venus de Milo. But it is the full-length nude portraits of Lee Miller that evoke the most powerful fascination.

No detail of her short, side-parted hair or full red lips is left to the imagination. The long-lashed eyes are cast down or stare out with a glazed expression. Without an ounce of spare flesh on her stomach, her pert breasts are crowned by nipples that are fully half the span of her aureole. It is a stirring vision of female beauty. Lee wanted to work side by side with Man Ray, not merely to pose for him, but her beauty won lavish praise from all who met her. In truth, Lee Miller was an unreliable lover, and her audacity with other men drew shocked, obsessive reprimands from the artist. When she went off with the wealthy Egyptian Aziz Eloui Bey, Man Ray responded by representing parts of her body in segments, such as in Object to be Destroyed, combined with instructions to the viewer, for example to dare to "Cut out the eye from the photograph of one who has been loved but is seen no more". The eye in question was Lee Miller's. It was a lurid, brutal attempt to defray the anguish that he was going through, a visual parallel to the "cut-up" writing technique that William Burroughs and others pioneered, though in Man Ray's case, it was he who was more "cut up" than anyone else. The years 1929 to 1931 saw Man Ray complete work on one of his most notorious photographs, *Le Primat de la matière sur la pensée* or, in English, The Primacy of Matter over Mind (or Thought).

By exposing the film prematurely, and not letting the background and image heal together, Man Ray found a way to create a sort of halo around the human form. He happened upon the technique while working in the studio with Lee Miller - and credit for its discovery is still hotly disputed by supporters of each. At first the technique was called "edge reversal" but became more popularly known as Solarization. The Primacy of Matter over Mind was published in the third issue of the journal *Le surréalisme au service de la Révolution*. It shows a woman, naked and apparently asleep but with her right hand cupping her right breast and her other hand up by her head.

29. *Anatomy*, c. 1930,
Cellophane dress,
Photograph,
30 x 24 cm.

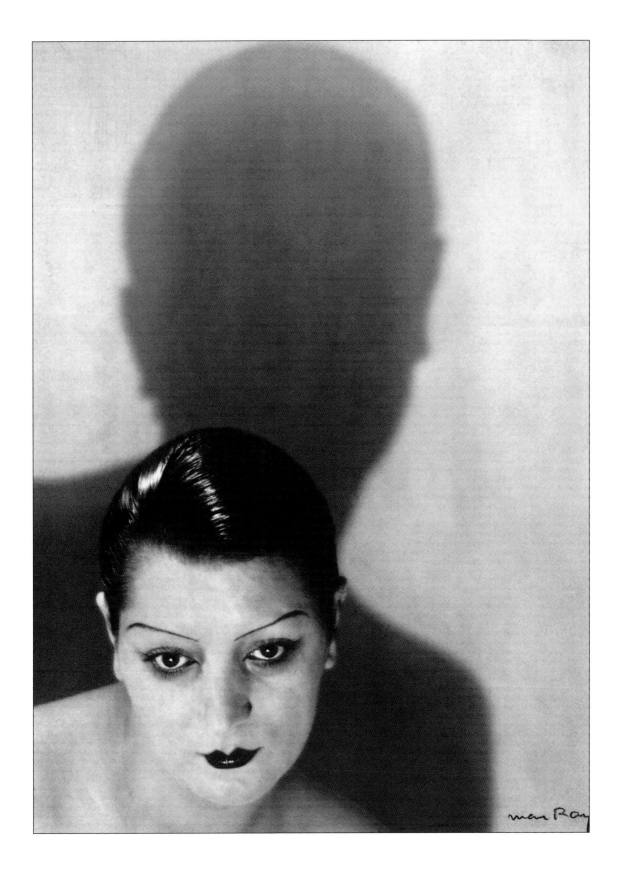

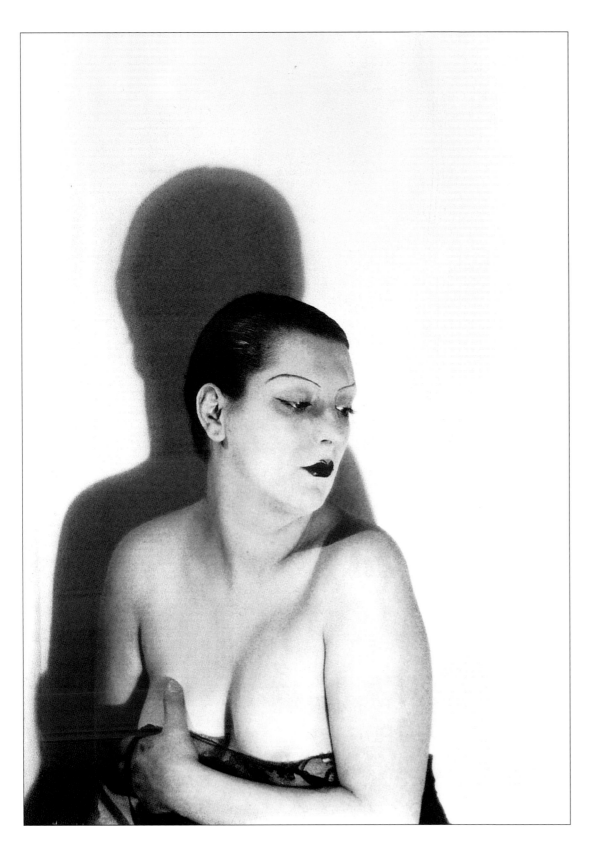

30. *Kiki de Montparnasse*,
 1926, Photograph.

31. *Kiki de Montparnasse*,
 1926, Photograph.

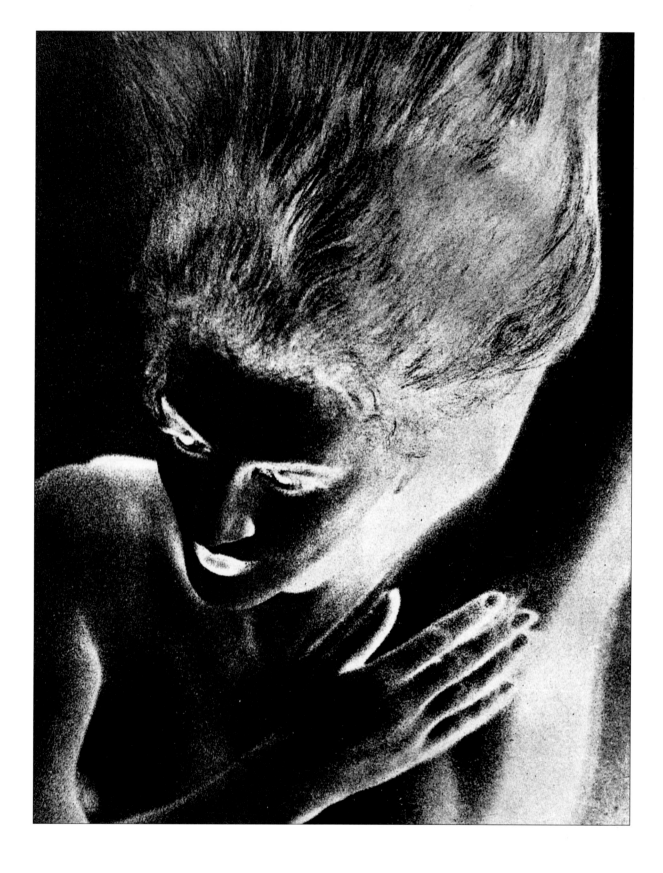

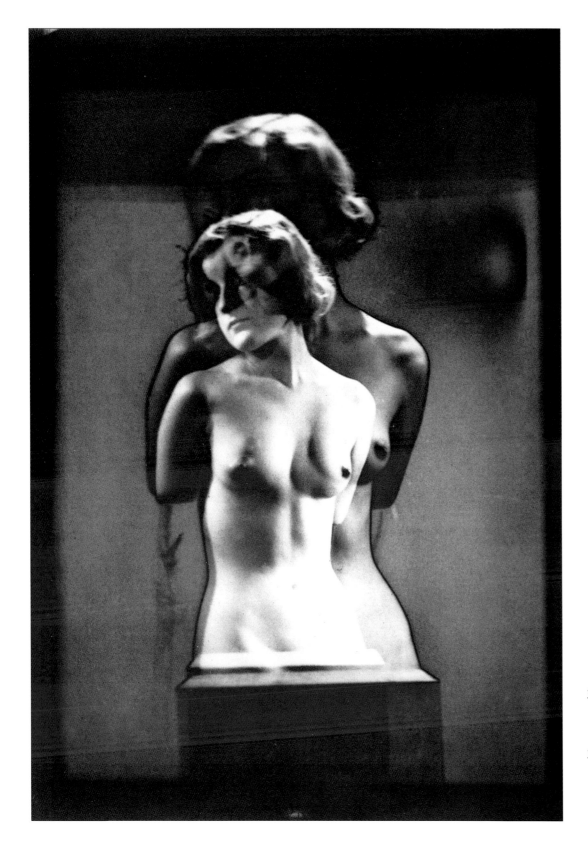

32. *Jacqueline Goddard*,
 c. 1930, Solarization.

33. *Feminine bust*,
 c. 1930, Photograph.

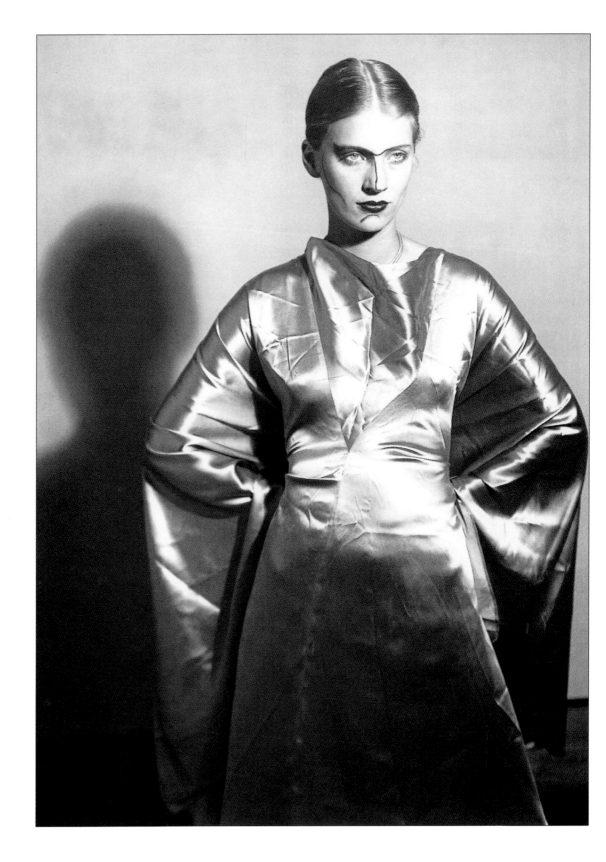

34. *Lee Miller*, c. 1930,
 Photograph.

35. *Lee Miller*, c. 1930,
 Photograph.

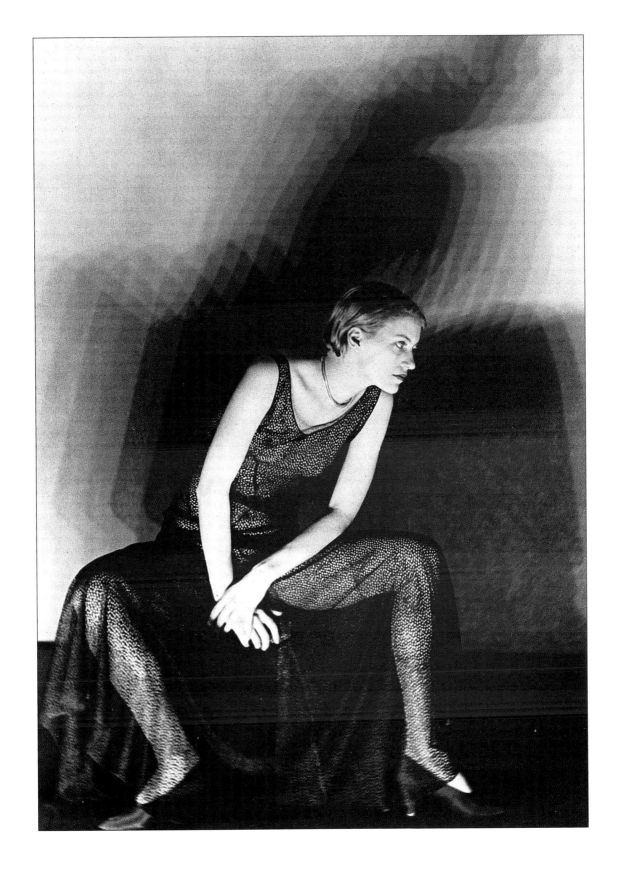

It's as if she is floating in thin air. The studies of the model called simply Natasha are classics too, as much for the beauty of the model as for their demonstration of his brand new photographic technique. There are a few tiny indications that the image has been interfered with, such as the hair which is in negative, and the model's left eye, which, half-obscured by her arm, reveals a faintly menacing corner of white, but apart from that, the area within the Solarized line is largely untouched by scientific processes, and we are left free to admire the body.

Man Ray's art never lost its power to shock, and when he was invited to contribute to the two long poems by Benjamin Péret and Louis Aragon in the book *1929*, he produced four images, *Printemps, Été, Automne, Hiver*. Grainy but verging on the pornographic, they dared to portray a man and a woman in various stages of intercourse. The penis is much in evidence, either inside the vagina or about to enter it, depending on the season. The following year, he shocked again with his 1930 study *La Prière* (Prayer). Whereas normally the act of prayer is associated either with clasped hands or bowed head, here we are shown a bare bottom, with feet and hands sticking out.

On its own, the pose is merely intriguing, but, combined with the title, it underlines Man Ray's deep mistrust of organised religion. Elsewhere in the series, a naked woman lies on her side, her long hair falling over her face and her pubic area exposed. In one photo her skin is intact and she lies alone but in another there is a puncture, and blood tumbles from the hole below her left breast, gathering like an unravelled ball of wool onto the bed on which she lies.

The blatantly iconographic connection between the woman and countless images of Christ on the Cross is hard to ignore. A man, clothed, lies face down over her outstretched leg, as if parodying one of the distraught disciples. In yet another in the same series, a man and a woman are seen, fully clothed, holding each other in a lingering embrace, their faces not touching. Above the woman's head, a mask, as if from a Greek sculpture, hangs from the wall casting a shadow.

A few years later, in 1933, Man Ray shocked again with his *Monument à D.A.F de Sade*, a soft-focus study of a pair of lop-sided buttocks with a line drawing of an inverted crucifix super-imposed on them. There are softer images from this period, too, such as the solarized image of *Les Larmes*, in which a close-up of an eye is delicately adorned with tiny baubles representing tears. The eyes look upward in a beseeching expression but the eyelashes are heavily lacquered. Are they ridiculing female crocodile tears, or pouring scorn on the men who are taken in by such sentimentalism? Lee Miller left Paris for New York in December 1932.

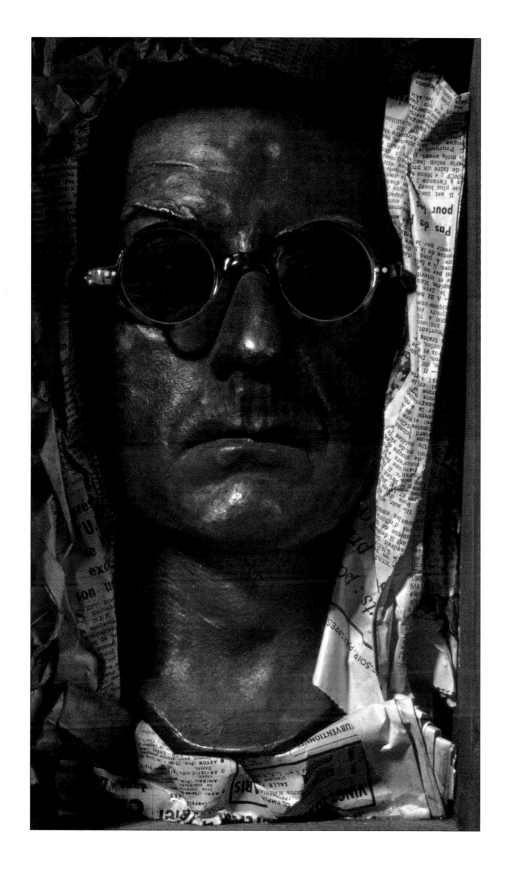

37. *Self Portrait*, 1932,
Bronze,
37.7 x 21 cm,
Private Collection.

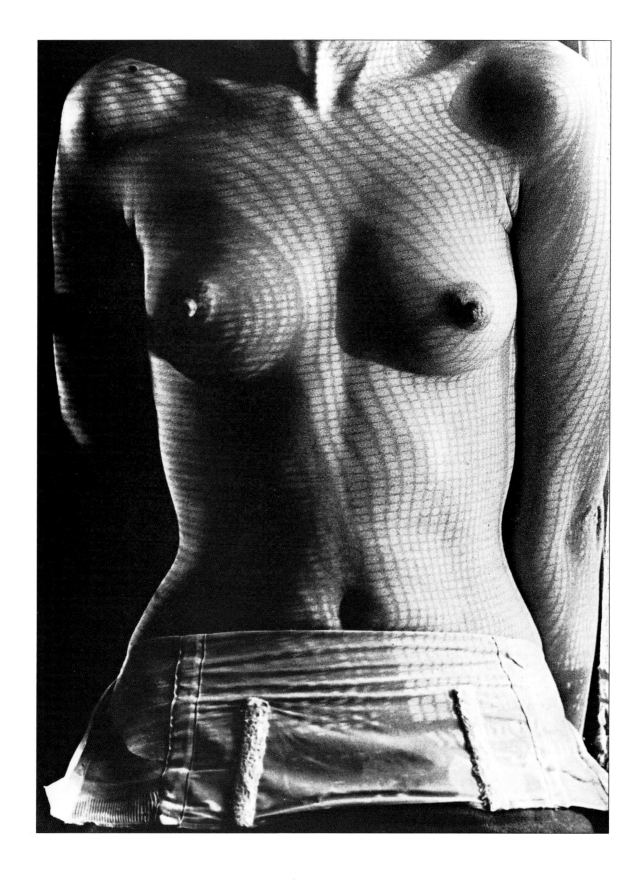

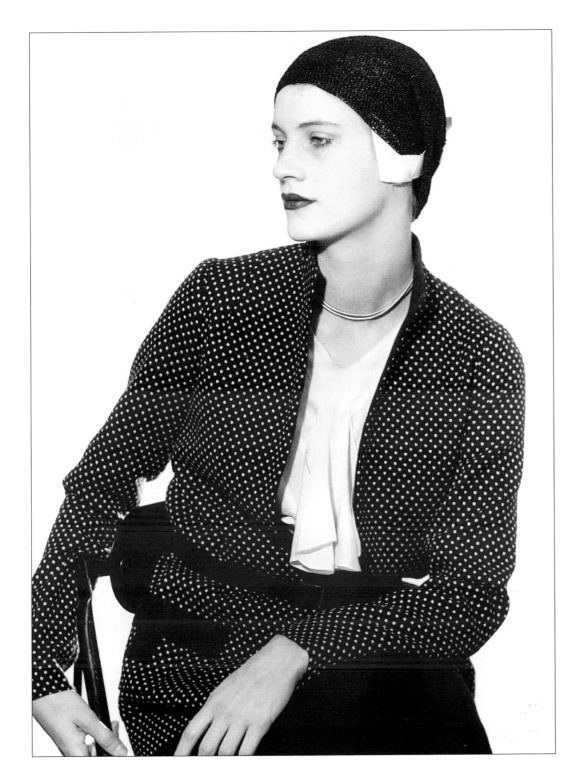

38. *Lee Miller*, c. 1930,
 Photograph.

39. *Lee Miller*, 1930,
 Photograph.

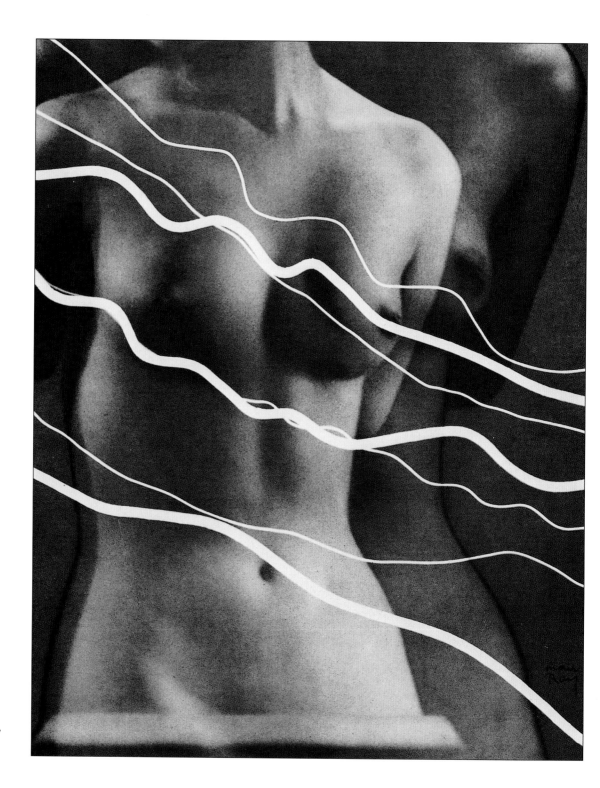

40. *Electricity*, 1931.

41. *Untitled*, Photograph,
 1931.

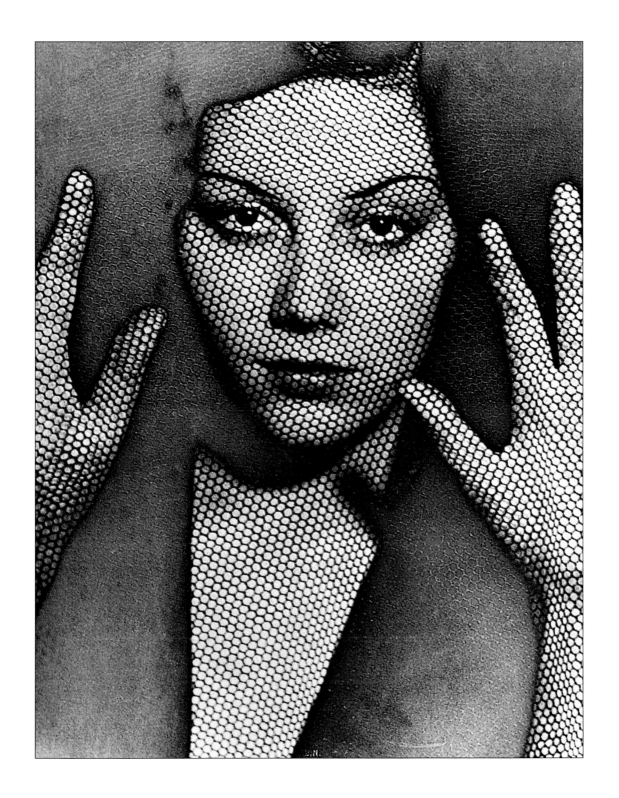

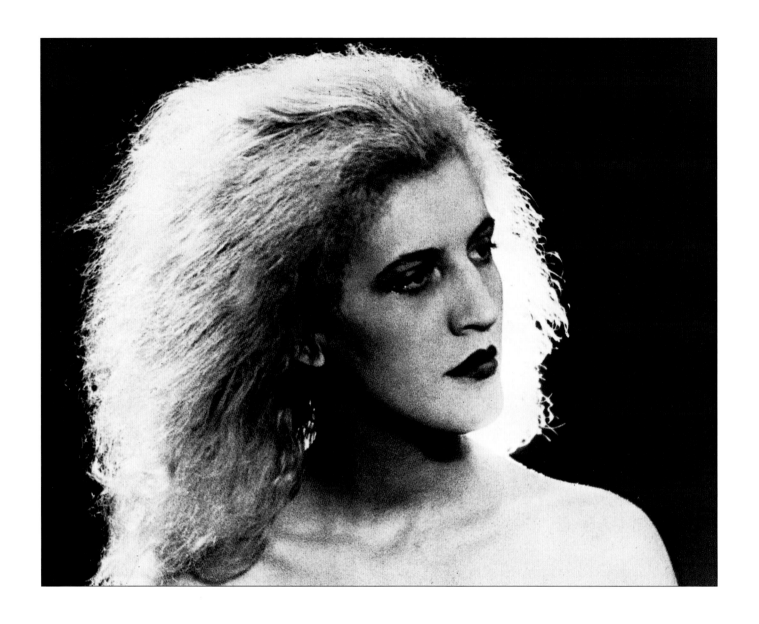

42. *Jacqueline Goddard*,
 1932, Photograph.

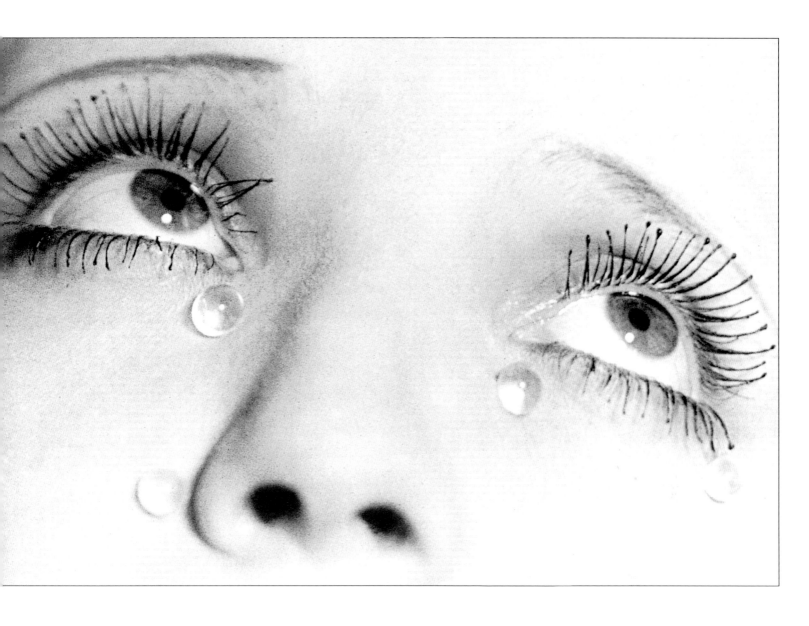

43. *Glass tears*, 1932,
Photograph.

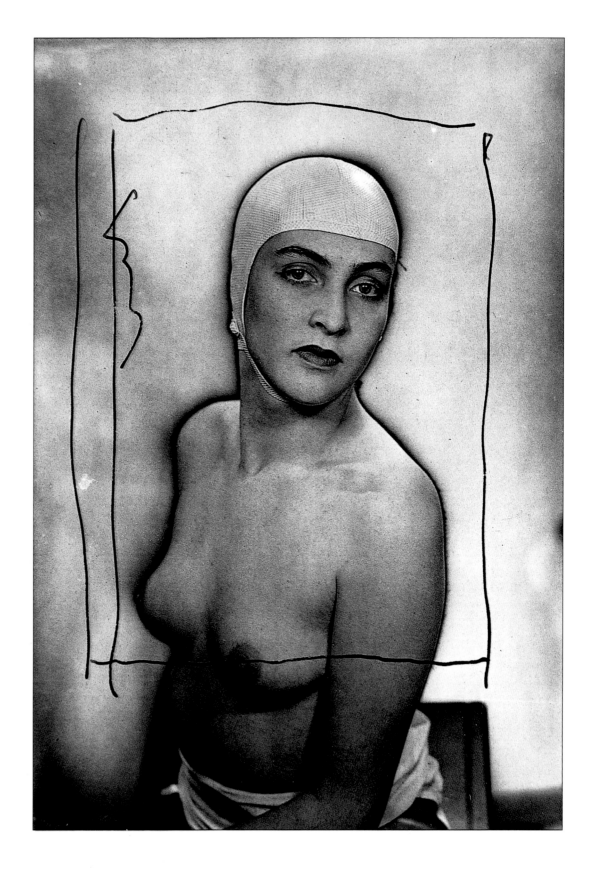

44. *Meret Oppenheim,*
1933, Solarization.

Over the course of her three-year marriage to Aziz, relations between Man Ray and his former lover slowly became cordial. Man Ray sank his feelings into painting the surrealist classic which he called *A l'Heure de l'Observatoire - Les Amoureux*, or in English, *Observatory Time - The Lovers*. Probably his most popular work of the 1930s, it became known simply as *The Lips*. In the course of composition the model for the lips started as Kiki, but after six months he realised that it was Lee Miller's straighter, less rounded lips he wanted, so he threw away his earlier version and re-attacked the project, using Miller's lips instead.

It was an awesome project; two years in completion. Having placed a canvas about eight feet long over his bed, he worked on it every morning for a couple of hours in his pyjamas, standing on his bed. In the lower left of the painting is the observatory that he used to pass every day on his way to his studio in the Jardins du Luxembourg. But by calling it *The Lovers* he compares the lips to a pair of lovers, "floating in the sky in blissful intercourse," as Arturo Schwarz described it. "Their ecstatic embrace defies time, space and gravity. They appear in an embodiment of Tantric philosophy." The critic Philip Rawson saw in it "a cult of ecstasy focused on a vision of cosmic sexuality."

Later, in a poetic text he wrote in 1935, Man Ray alluded to the painting again: "The only reality, the thing that gives importance to dreams, reluctant to wake up, your mouth is suspended in the void between two bodies. Your mouth itself becomes two bodies, separated by a long, undulating horizon. Like the earth and the sky, like you and me... Lips of the sun, you ceaselessly attract me, and in the instant before I wake up, when I detach myself from my body... I meet you in the neutral light and in the void of space, and, sole reality, I kiss you with everything that is still left in me - my own lips."

Man Ray had been making some inroads into the fashion pages of magazines like Vanity Fair and Vogue, but Harper's Bazaar proved to be a much more attractive, and lucrative, proposition. Alexey Brodovitch, an immigrant from Russia, arrived in Paris in 1920 and was soon making his mark in that magazine as the most influential art director of his day. Being a friend and admirer of Man Ray, he was keen to employ him, and Man Ray was rewarded with such assignments as most photographers could only dream of: exclusive coverage of the Paris openings in six and eight-page spreads.

Man Ray's fashion photographs came to dominate the pages of Harper's Bazaar magazine in the late Thirties, and the famous photographer Richard Avedon gave him credit for "breaking the stranglehold of reality on fashion photography." Like Brodovitch, Ray was a radical, but he didn't want to achieve the new by what Baldwin calls "ostentatious displays of virtuosity".

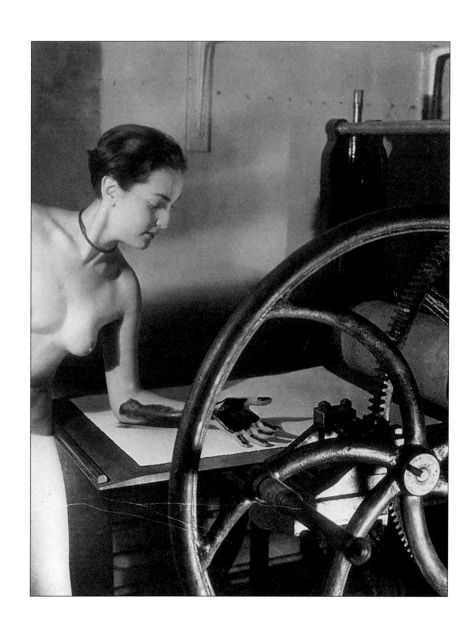

45. *Veiled Erotic*, Meret
 Oppenheim, 1933,
 Photograph.

46. *Veiled Erotic*, Meret
 Oppenheim, 1933,
 Photograph.

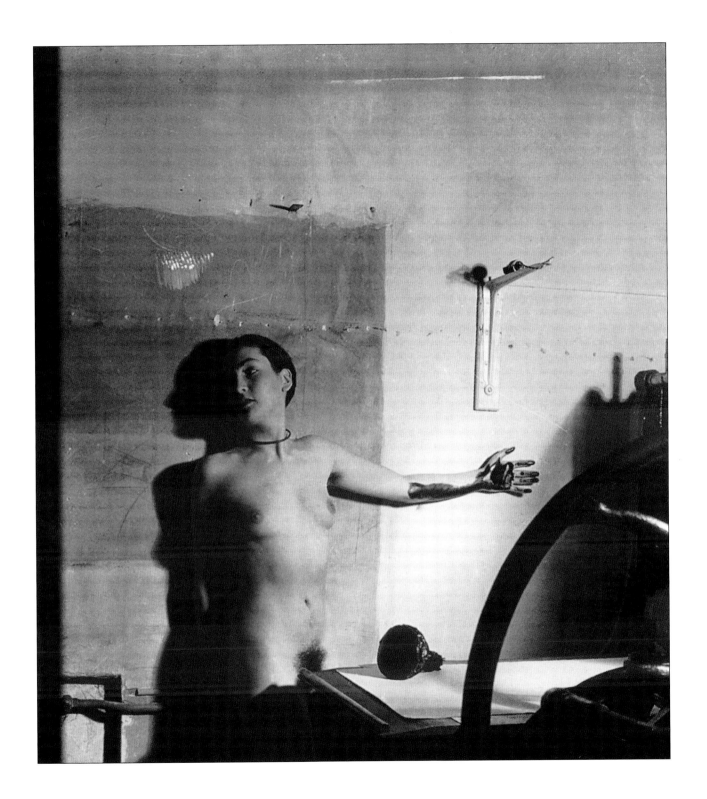

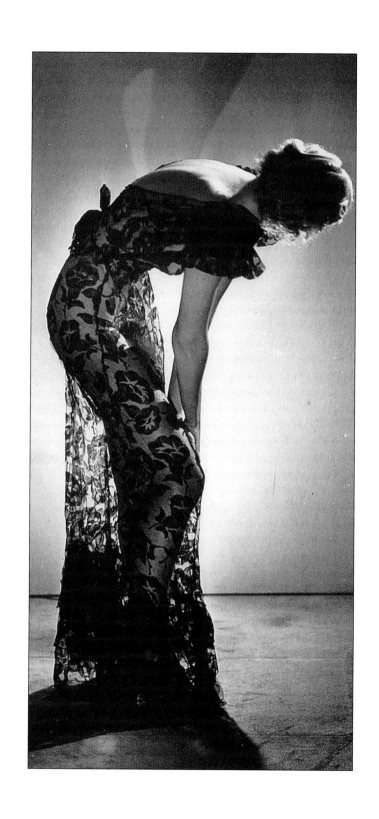

47. *Fashion Photograph,*
c. 1935.

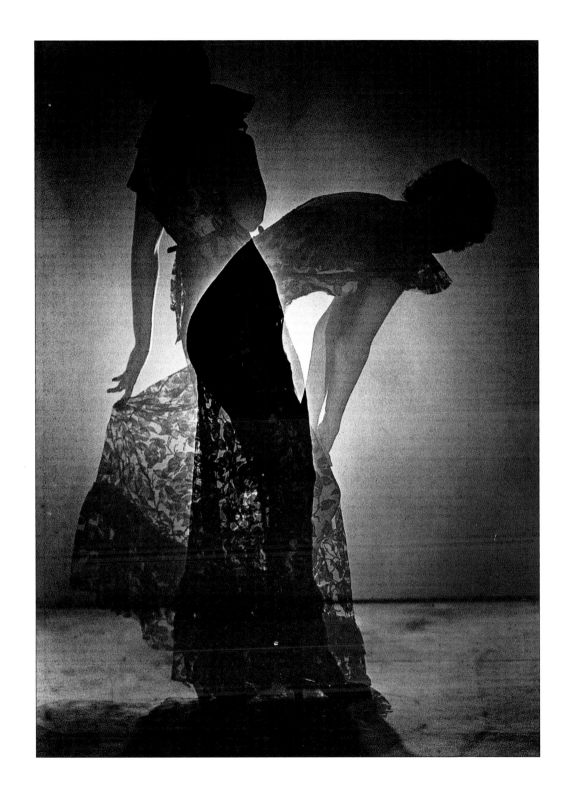

48. *Fashion Photograph,*
c. 1935,
Superimposition of
two pictures.

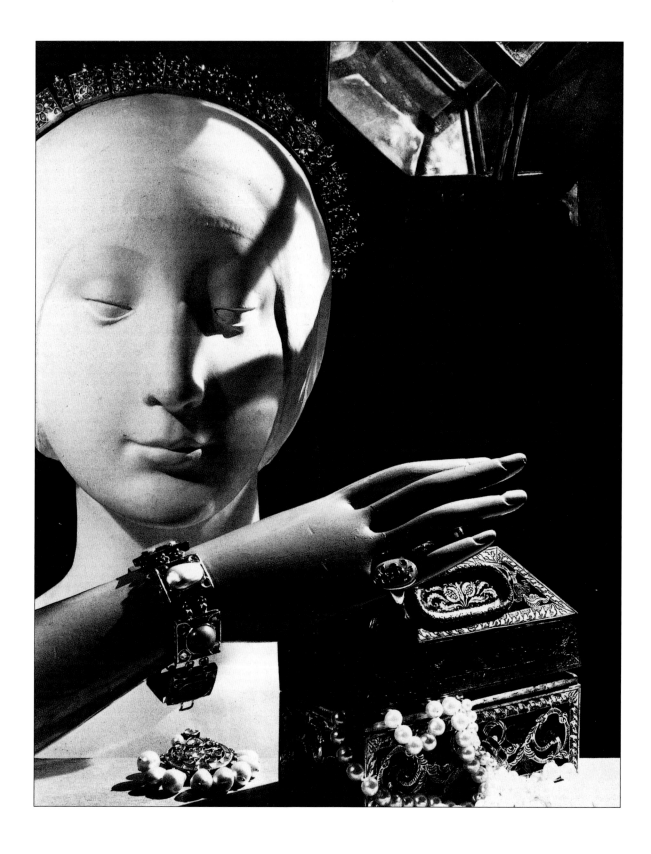

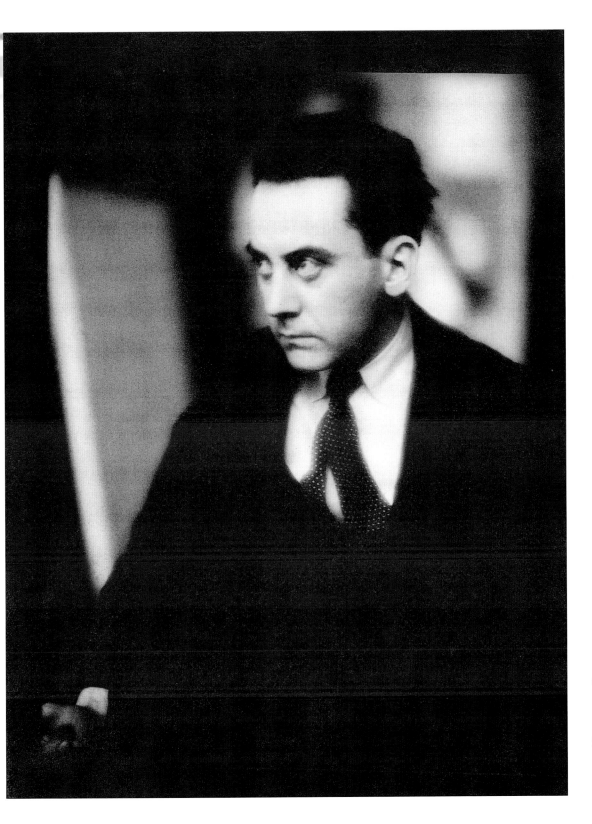

49. *Jewelry*, for Harper's
 Bazaar, 1935.

50. *Self Portrait*, 1924,
 Photograph.

Man Ray's fashion portraits from this period are characterised by the effects of what he called "photofloods", creating a bright but short-lived light that threw multiple shadows and gave the works a haunting quality. For Man Ray, it was a highly lucrative assignment. He was soon dressing in the height of fashion, and within two years had earned enough to buy a Peugeot motor car and a second home in the suburbs at St Germain-en-Laye. By now, society types all over Europe were falling over each other to pose for Man Ray. Some, like Coco Chanel and Elsa Schiaparelli, preferred to keep their clothes on, while others were less circumspect.

In 1933, the great photographer was introduced to Meret Oppenheim, the daughter of a German physician and a Swiss mother. She had grown up in Bern and Basle, and by the time she moved to Paris at the age of eighteen she was already an accomplished artist. She studied for a while at the illustrious Académie de la Grande Chaumière, but soon dropped out to pursue more subversive activities in the art world, and to further her reputation.

Man Ray often photographed her naked, sometimes appearing himself, inappropriately fully clothed, standing behind her with a tender expression on his face. Elsewhere, Meret Oppenheim peers out with an expressionless face, her head wrapped in a bathing cap above her jutting breasts. In another famous shot, ...*Erotique Voilée*, for the lavishly produced art periodical *Minotaure*, she posed against the huge iron flywheel of an etching press, with only a band around her neck and her pubic hair very clearly in frame.

In another shot in the same series, the purity of her white skin is contrasted with a smudge of printer's ink on one arm. In others, the painter Louis Marcoussis, wearing a clip-on beard and looking ludicrously over-dressed in comparison with the naked woman, adds a touch of surreal slapstick by appearing to be about to wipe the ink off her arm with a white cloth.

51. *Nude in front of the painting "A l'heure de l'observatoire, les Amoureux" (Observatory Time – The Lovers),* 1936, Photograph.

Later, Meret Oppenheim again proved her capacity to shock, or to self-publicise, in the name of art. In 1958, at the launch of the Exposition Internationale du Surréalisme in Paris, she lay stretched out on a table at the inaugural banquet, her naked body covered with food, the pose suggestive of a love-bed.

Throughout his life, Man Ray made studies of his friends, both male and female. As well as his *Self-Portrait with Camera* from 1931, he took several shots of his friend Pablo Picasso's *inamorata*, the beautiful Yugoslavian photographer Dora Maar.

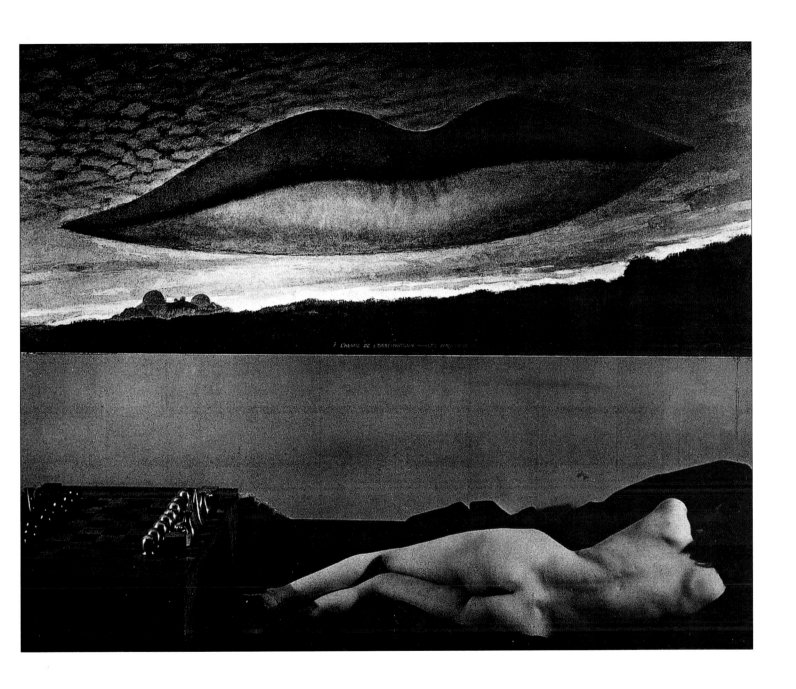

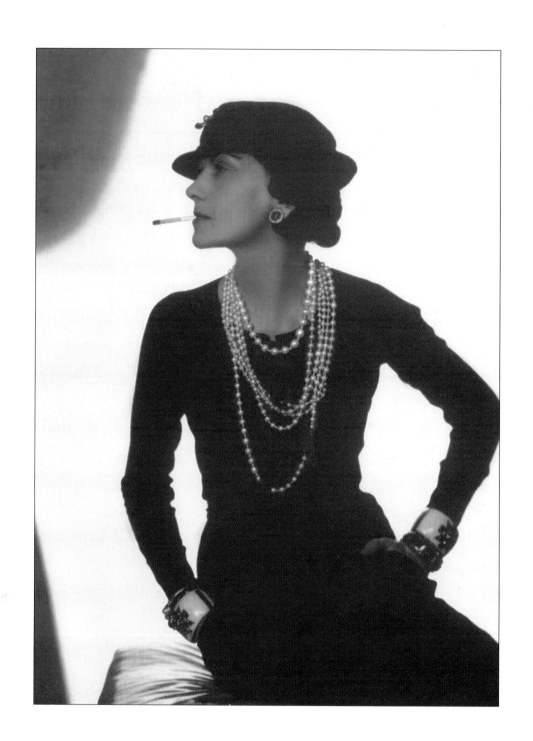

52. *Coco Chanel,* 1935,
 Photograph.

53. *Nusch with a mirror,*
 1935.

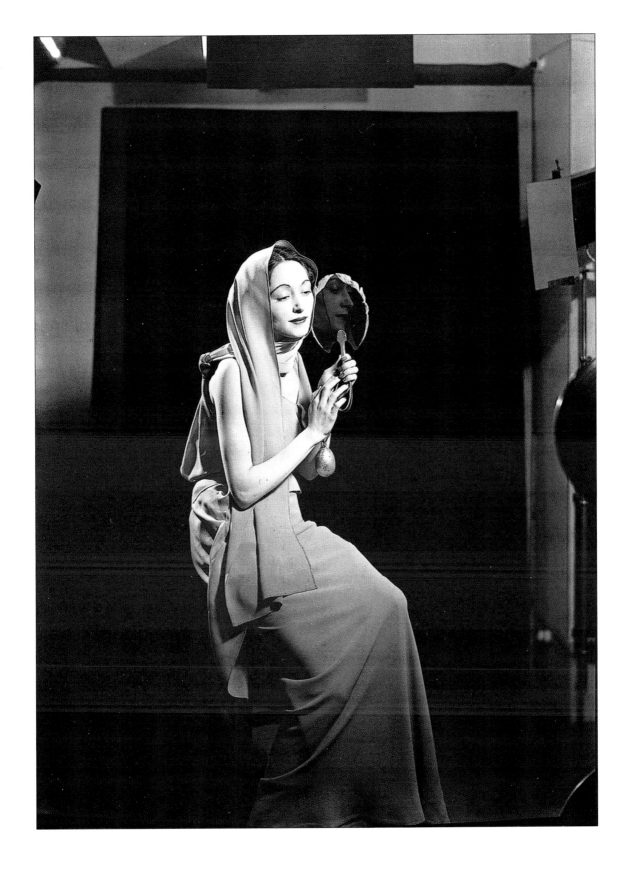

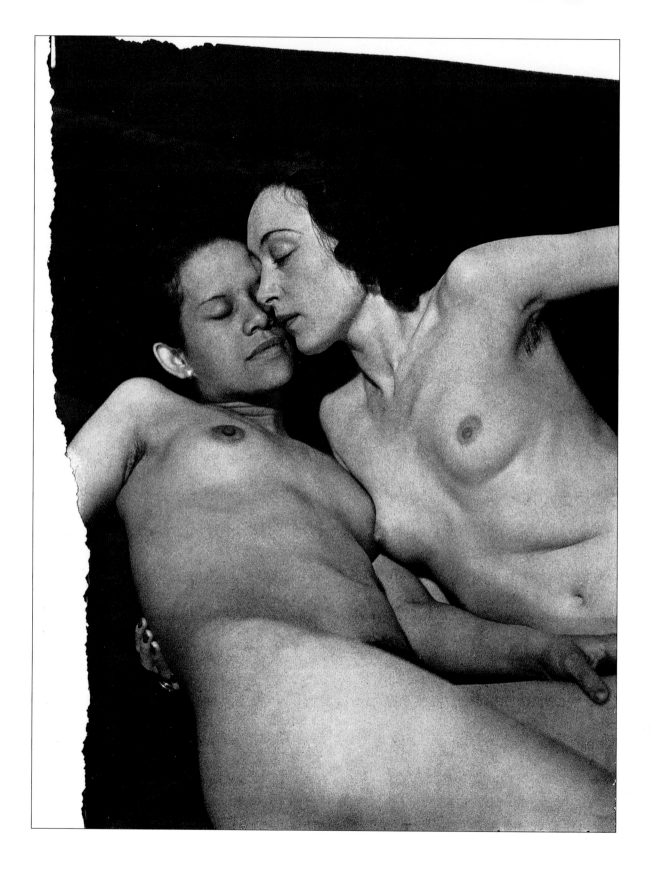

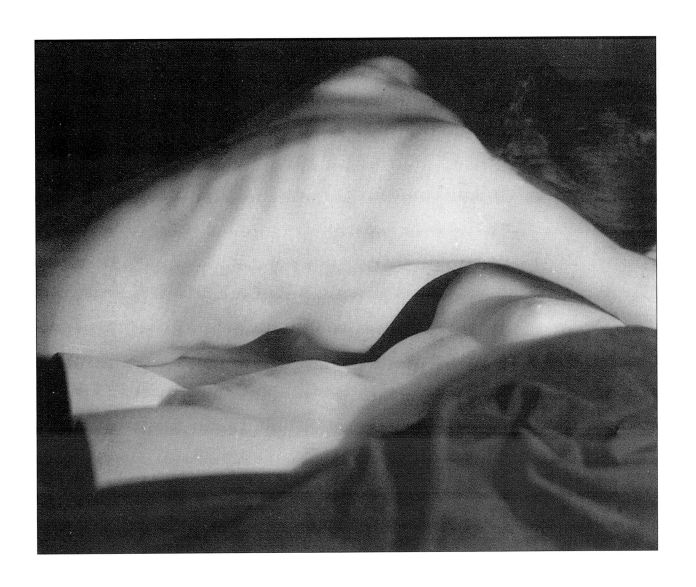

54. *Ady and Nusch
 Eluard*, 1937,
 Photograph.

55. *Untitled*, 1936,
 Photograph.

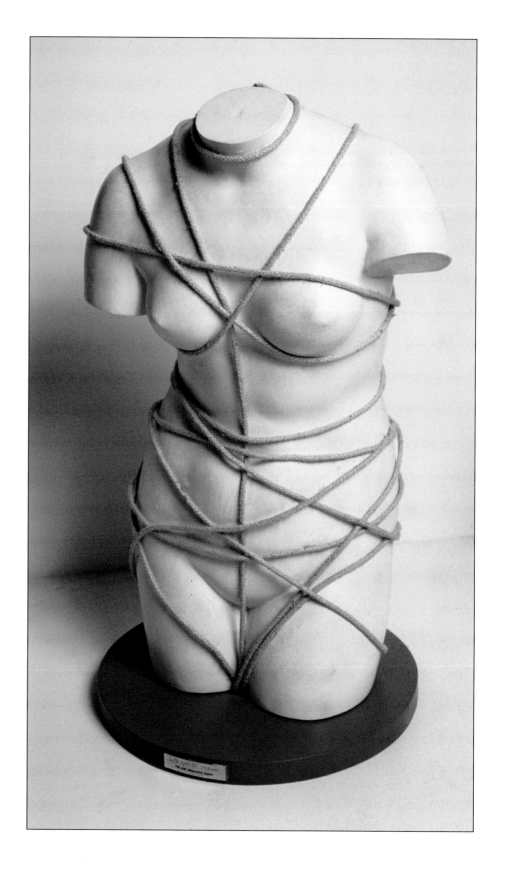

56. *Restored Venus,*
 1936-1971,
 Plaster and rope,
 height 61 cm,
 Private Collection.

57. *Dora Maar*, 1936,
 Solarization,
 23 x 30 cm,
 Private Collection.

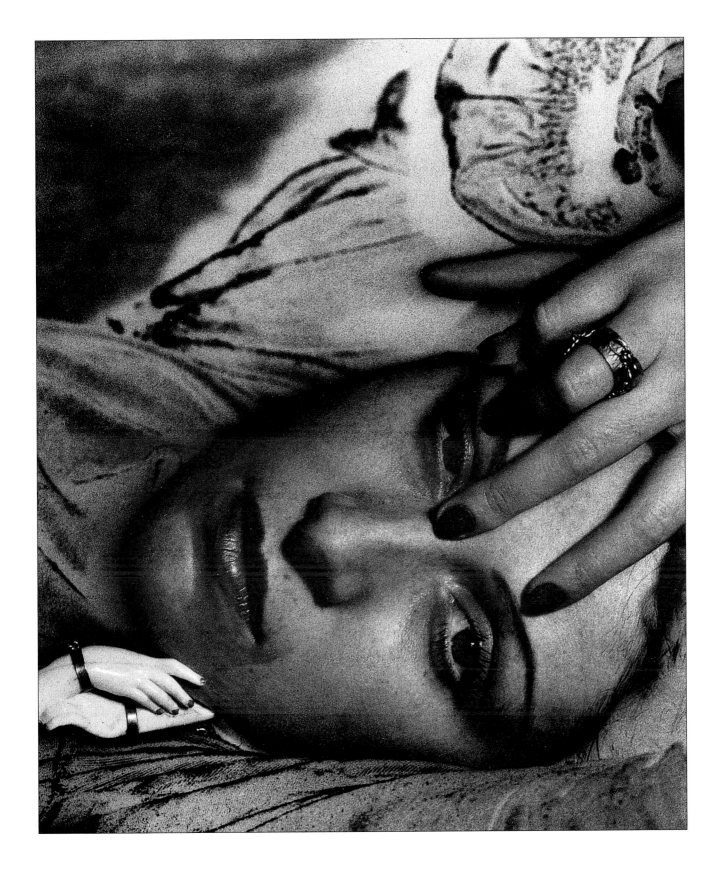

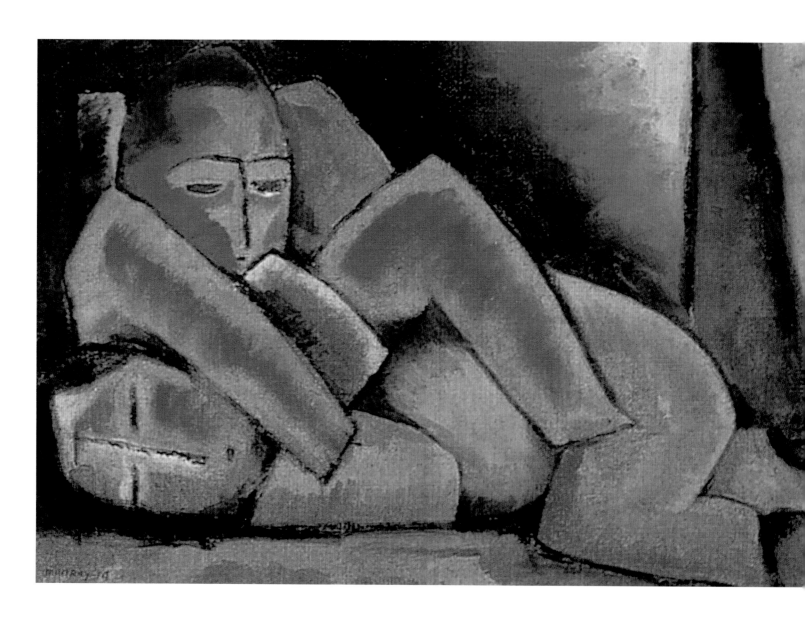

In the summer of 1936, Man Ray had taken up with Adrienne ("Ady") Fidelin, a dancer who came from Guadeloupe. The two couples joined the poet Paul Eluard and his beautiful wife Nusch in the Eluards' house at Mougins, in the hills overlooking Cannes. They enjoyed long walks along the beach looking for driftwood. After lunch, Man Ray records in his journal, the couples "retired to their own respective rooms for a siesta and perhaps lovemaking". At a ball, in the summer of 1937, topless and with Ady similarly topless by his side, Man Ray bumped into the newly divorced Lee Miller.

It was the first time they had met in five years. Man Ray introduced her to Roland Penrose, and the two were soon a couple. Eluard and Nusch, Lee and Roland, Man Ray and Ady, and Picasso and Dora Maar returned to Mougins. Man Ray was intrigued by Dora Maar, whose amused but rather disdainful expression he photographed close up. He couldn't, though, stop taking photographs of Nusch.

The pictures he made of her are simple, unadorned, intimate and friendly, more like those from a family snapshot album than self-consciously artful. There is also a memorable image of Ady and Nusch from the same year. Nusch is lying against Ady, their breasts touching, olive-dark skin contrasted with white skin, their eyes closed in expressions of restful concentration. The gently Sapphic tone of the picture hardly needs underlining.

It looks like a study from a life class, as if Man Ray had set out to paint them with oils, but happened to have his camera ready. Man Ray never looked so comfortable with friends of his own sex. He must have known that he could never adopt such a pose with his lifelong friend Marcel Duchamp. Man Ray's heart finally came to rest on the bosom of Juliet Browner, whom he met on his return to America in 1940.

He was fifty, and she was just twenty-eight, but they got on instantly. Man Ray had finally found his soul mate. It wasn't until six years later that they married, but the relationship was a happy one, and he photographed her many times. He died, thirty years later, on 18 November 1976. Energetic, constantly changing as it chases its elusive prey, Man Ray's legacy is in the ecstatic profusion of forms.

Nearly every image is part of a series, part of a variation, so that every viewpoint has to be judged against the next, and the one before. Throughout his long life, Man Ray continued to explore and appreciate female beauty in its infinite variety of forms. One of his most impressive achievements is that, in his vast body of work, we can feel in every frame, stanza or canvas, the excitement of finding oneself in the presence of women.

58. *Lovers*, 1914,
Oil on canvas,
24 x 35.2 cm,
Collection Sylvio
Perstein, Antwerp.

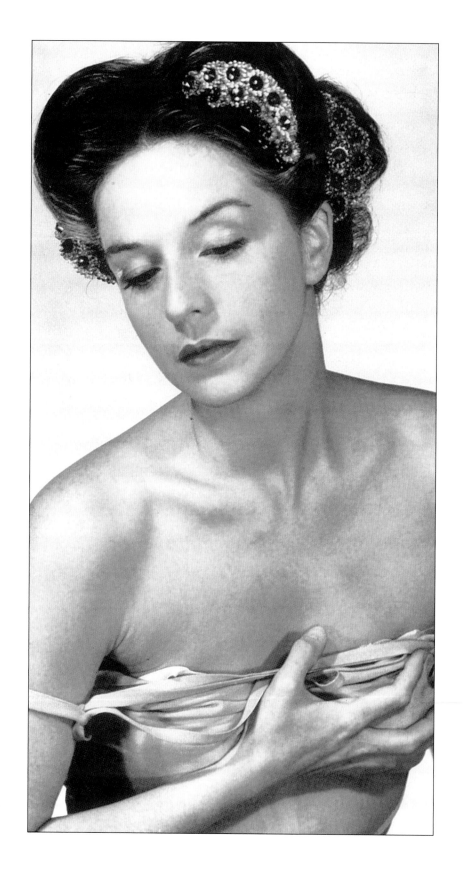

59. *Fashion Photograph,*
 1937.

60. *Fashion Photograph,*
 1937.

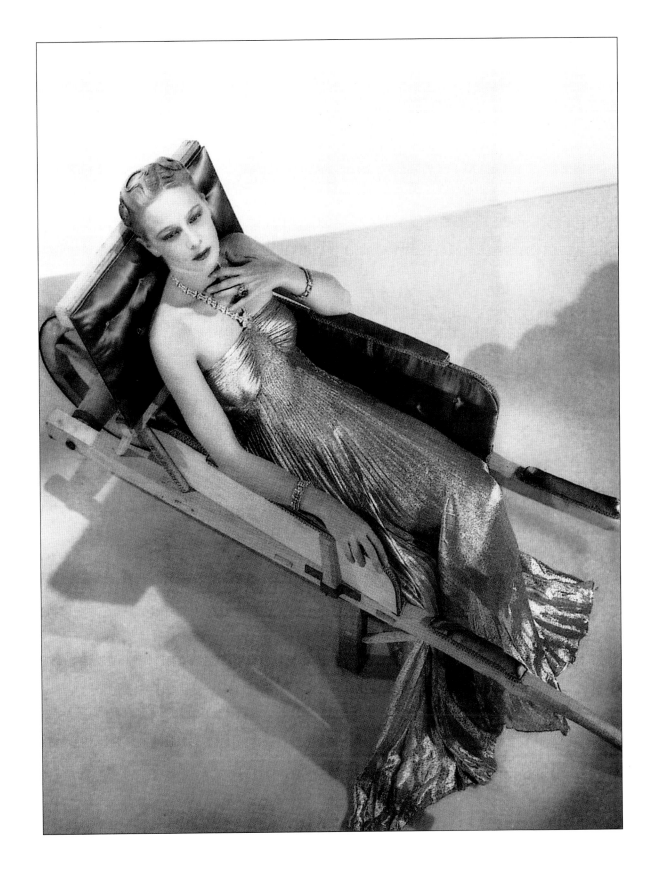

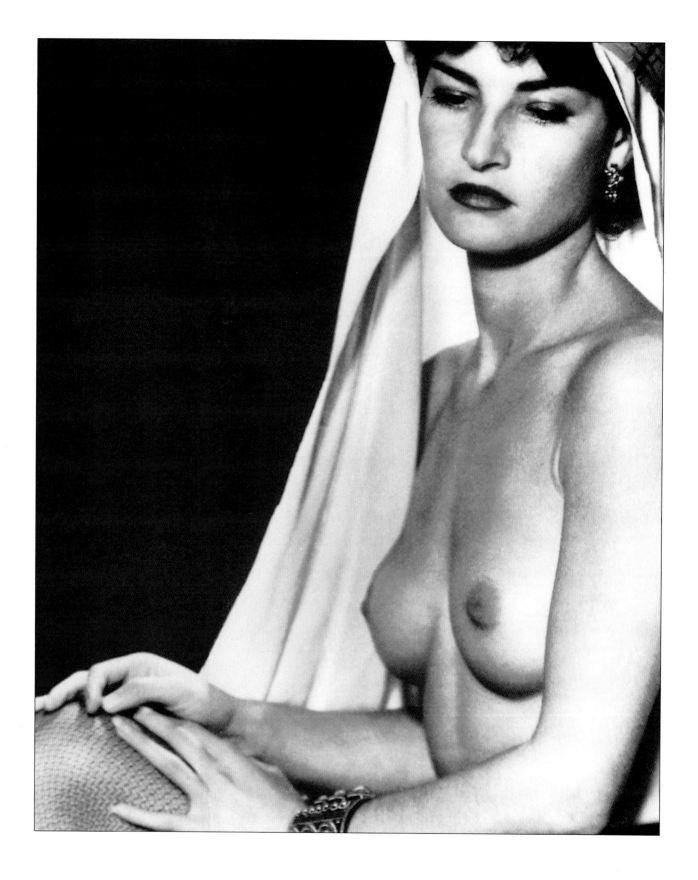

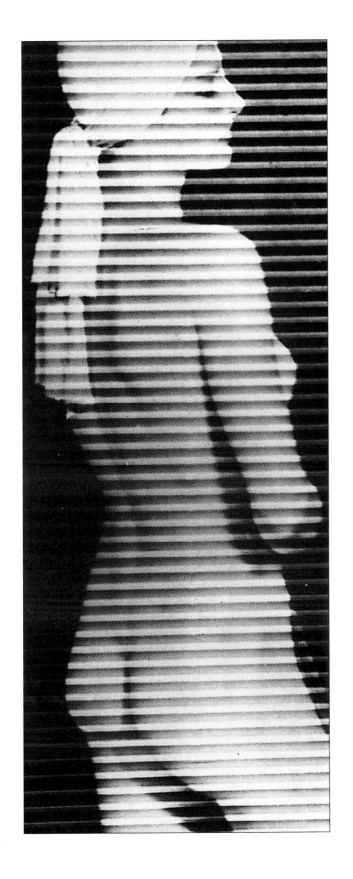

61. *Juliet*, 1945,
 Photograph.

62. *Juliet*, 1945,
 Photograph.

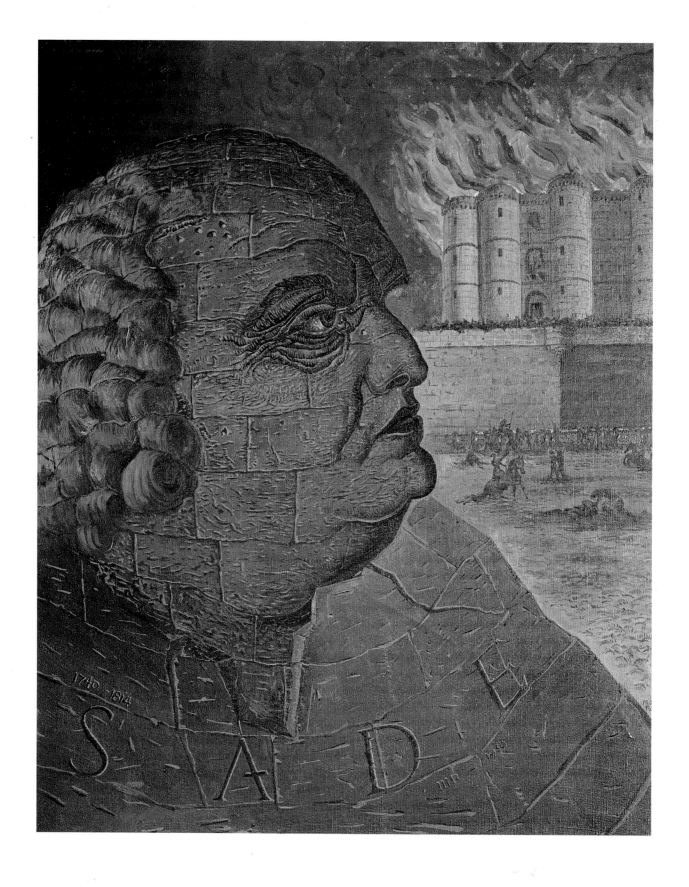

BIOGRAPHY

1890: Birth of Emmanuel Radnitsky, 20th August, in Philadelphia (Pennsylvania).

1897: His family settles in Brooklyn (New York).

1904: He receives his secondary school education and takes lessons in free drawing and industrial drawing.

1908: Radnitsky gains a scholarship to study architecture but gives it up very quickly.

1910-11: He begins to frequent the Ferrer Centre. This centre functions on the libertarian principles, getting rid of drawing and watercolour lessons. "Indeed all was free there, even love". At the same time he frequents the famous 291 gallery of Alfred Stieglitz, who allowed him to discover avant-garde art.

1911: He settles in New York.

1912: In Spring, Radnitsky decides to move out to Ridgefield, in New Jersey. He works as a commercial artist.

1913: He visits the Armory Show and discovers European avant-garde. He meets Marcel Duchamp and Francis Picabia in New York. He paints his first cubist painting: *Portrait of Alfred Stieglitz*. He also meets Donna Lecoeur (Adon Lacroix), a poet of French culture who makes him read Baudelaire, Rimbaud, Lautréamont, Mallarmé, Apollinaire. To earn his living, he works at the same time as a designer with a cards and atlas editors: He will stay there until 1919. He attempts to create a community of artists at Ridgefield with the poet Alfed Kreymbourg. His first exposition takes place. He calls the works of this period "cubism-romantic-expressionist".

1914: In May, he marries Adon Lacroix, with whom he lives at Ridgefield. He has abandoned his family name and called himself Man Ray, as seen at the register of his marriage. The war having escalated in Europe, his project to go to France with Adon must be reconsidered. He produces calligraphies for Adon's texts and enriches the drawings and lithography.

1915: He buys a camera in order to reproduce his paintings. He comes back to New York, settling in Lexington Avenue.

1916: With Marcel Duchamp, he participates in the "dada" movement in New York. He paints *The Rope Dancer Accompanies Herself with Her Shadows*.

1917: He participates in the review of *The Blind Man*. John Quinn employs him to photograph all the art works he possesses. He paints *Suicide*, one of his first aero graphics. He makes his first glass plate.

1918: Ferdinand Howall begins to collect Man Ray's works. Takes up again *The Rope Dancer Accompanies Herself with Her Shadows* in aero graphics.

1919: In March, he publishes the one and only number of *TNT*, viewed as having anarchist tendencies. He breaks with Adon.

1920: Corresponds with Tristan Tzara, famous representative of the Dada Movement. Photographs in collaboration with Marcel du Champ.

1921: He wins ten dollars for the portrait of sculptor Berenice Abbott, competing with John Wanamaker's photographs. He makes a film with Marcel Duchamp: *Madame la Baronne Elsa von Freytag Loringboven shaves her pubes*. Man Ray publishes *New York Dada* with Marcel Duchamp. Marcel Duchamp leaves New York 21st June for Paris. In July, Man Ray joins him and arrives in Paris. Marcel introduces him to the Dadaists. There, he makes the aquaintance of other people such as Jean Cocteau and Erik Satie.

In the company of the latter he produces *Cadeau*: an iron cross spiked with nails, which reflects the destructive humour of Dada. His photographic research leads him with Duchamp to discoveries in the optical domain, and results in *Anemic Cinema*. In the Paris of the 1920s, Man Ray, like all other artists of the time, meets Kiki of Montparnasse. In November, he decides to settle himself in the Hotel des Écoles, rue Delambre at Montparnasse, the artists' district.

1922: First rayographic. He makes numerous portraits of those most well known in the world of art: Gertrude Stein, Georges Braque, James Joyce, Jean Cocteau... Not only does he photograph his friends but he also becomes the fashionable photograph for the collections of Paul Poiret.

17th Febuary: he signs the resolution proposed by Tristan Tzara against André Breton's Paris Congress.

18th November: at the request of Jean Cocteau, he takes a photograph of Marcel Proust on his deathbed.

Appearance of *Delicious Fields*: 12 rayo graphics, preface by Tristan Tzara, forty examples.

He makes his first film: *Return to Reason*.

1923: "In 1923, I was an established photographer." He takes on Bérenice Abbot as assistant until 1926.

1924: Literature published: *Ingres' Violin*.

63. *Imaginary portrait of D.A.F. de Sade (1740-1814)*, 1938, Oil on canvas, Private Collection.

1925: Exposition of decorative art. Man Ray photographs the haut-couture section. In May, the French and American editions of *Vogue* publish his fashion photographs.

1926: Publishes *Revolving Doors*, ten stencils reproducing the 1916-17 collage.

1927: Signs "Hands of Love" in favour of Charlie Chaplin in the *Révolution surréaliste*.

64. *Rayograph*, 1965, Black and white Photograph, 28.5 x 24.5 cm, Private Collection.

1928: 13th May: Ursulines Studio, first of *The Sea Star*, a film made by Man Ray about a poem by Desnos. Publishes in *Vu* a photographic report about the great Lorraine industries.

1929: In Biarritz, Lee Miller becomes his assistant until 1932. Publication of *1929*, poems by Louis Aragon and Benjamin Péret illustrated with four pornographic photographs by Man Ray. The work is seized. Shows *Mystères du Chateau du dé* at the Ursulines Studio.

65. *Metronome (Object to be destroyed)*, 1923-72, Wood, metal and paper, 23 x 11 x 11 cm, Hamburg Kunsthalle, Hamburg.

1930: Countess Pecci-Blunt has a white evening dress ball. With the help of Lee Miller, he puts film images, coloured by hand, on the white clothes of the guests. Monographics of Georges Ribemont-Dessaignes.

1931: *Electricity*, portfolio of ten rayo graphics with preface by Pierre Bost.

1933: Paints the picture *A l'heure de l'observatoire, les amoureux*. Journey to Hamburg. During the Summer, he rejoins Duchamp and Mary Reynolds in Cadaqués. They will go next to Barcelona where he meets Salvador Dalí and his wife Gala.

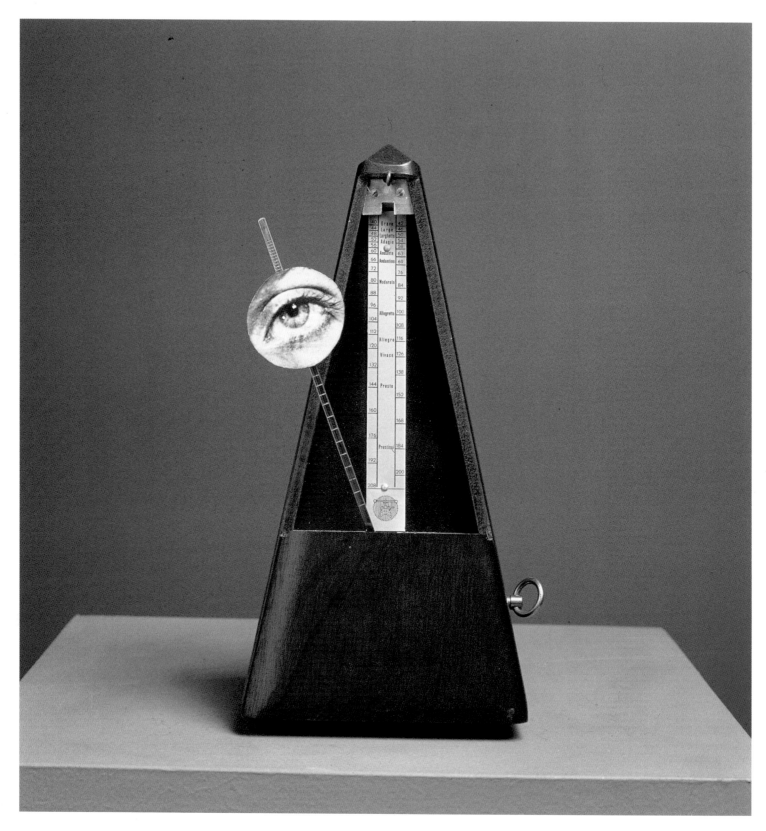

1934: *Man Ray Photographs, 1920-Paris, 1934.* Preface and photographs by Man Ray, text by Paul Eluard, André Breton, Marcel Duchamp and Tristan Tzara.

1935: He moves to Denfert-Rouchereau in Paris. Following this, he buys a house at Saint-Germain-en Laye, in the Parisian region. Affair with Adrienne Fidelin (Ady). He spends the summer at Mougins: Adrienne and himself, Paul Eluard and Nusch, Roland and Valentine Penrose, Pablo Picasso and Dora Maar, plus the Afghan Kaslek. He goes to New York to participate in the "Fantastic Art, Dada, Surrealism" exposition in the New York's Museum of Modern Art.

1937: He makes his last film (in colour) with Picasso and Paul Eluard. *Photography is not art*, twelve photographs, preface by André Breton.

1938: Paints *The Imaginary Portrait of Sade's D.A.F.*

1940: He leaves Paris with Adrienne and returns to the United States with her. Arrive in Hollywood. He meets Juliet Browner.

1941: He settles himself in a large studio in Vine Street. He redoes some works, some of them very old, such as *The Revolving Doors.*

1944: Hans Richter paints *Dreams that Money can Buy:* six dreams about the scenarios of Calder, Duchamp, Ernst, Léger, Man Ray, Richter, with music from Varèse, Cage, Bowles, Millhaud, Latouche. Richter asks Man Ray to film one of the scenes of the film. Man Ray refuses and sends him a scene: *Ruth, Roses and revolvers.* Man Ray holds a conference on surrealism. "To this end, I construct an object which would be an illustration of the surrealist act". At the end of the conference, he organizes a lottery game and gives the object to the winner. Double wedding in Beverly Hills of Man Ray and Juliet Browner and of Max Ernst and Dorothea Tanning.

1948: Paints the series *Shakespearean Equations,* in the thirties according to the photographs of the mathematical objects. He publishes two texts, *To be Continued Unnoticed,* at the time of the *Shakespearean Equations* exposition.

1949: He photographs Ava Gardner.

1950: He moves to a studio in rue Férou in Paris. He takes up painting again and makes photographs in colour.

1958: Series of *Natural Paintings*. Collaborates in the *Dadamade* catalogue.

1961: Gold medal for the photograph of Venice at Biennale.

1963: *Portraits*, preface by L. Fritz Gruber.

1966: Fiftieth anniversary of Dada.

1967: An exposition takes place at the American Center, Paris: *Recognition of Man Ray.*

1968: Marcel Zerbib puts out hundreds of works by Man Ray.

1970: *Mr and Mrs Woodman*, preface and 27 photographs of wooden models by Man Ray.

1971: Two retrospectives: Boymans von Beuningen Museum (Rotterdam), Galeria Schwartz (Milan): 225 works from 1912 to 1971.

1972: The retrospective in Rotterdam is presented in Paris at the National Museum of Modern Art.

1974: Andy Warhol dedicates to him a series of tables and a serigraphic.

1976: Man Ray dies in Paris 18th November.

LIST OF ILLUSTRATIONS